THAMES AND HUDSON

TATE GALLERY LIVERPOOL

Rachel

Whiteread

Shedding Life

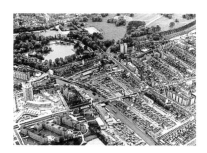

LIBRARY
ST. LOUIS COMMUNITY COLLEGE
AT FLORISSANT VALLEY

The small photographs of places and processes throughout the book were taken by Rachel Whiteread.

Contents

Preface

Rachel Whiteread was first nominated for the Turner Prize in 1991, and was awarded the prize in 1993. The same year, she confirmed her increasing national and international reputation with *House*, the sculpture cast from a condemned terraced house in East London. In November 1996, her Holocaust Memorial, one of Europe's most prestigious commissions this decade, will be inaugurated in Judenplatz in Vienna.

Tate Gallery Liverpool is delighted to present a selection of Rachel Whiteread's work from 1988 to 1996. Whiteread's large, public sculptures are complemented by intimate pieces on a more domestic scale. Her work has to do with space, objects and materials. Casting the spaces in, under or on every-day objects, she interrogates the familiar; looking under the carpet and inside the wardrobe at the spaces and structures amongst which we live. The present exhibition focuses on these intimate sculptures.

Sculptures cast in plaster, rubber and resin, a set of prints and photographs of *House* trace the development of a coherent artistic project from the early plaster and felt *Closet* to the most recent sculptures made this year. This is the most substantial showing of Whiteread's work so far in Britain. The exhibition offers the opportunity to experience her sculptures together, as they work best; changing and offering new meanings in the relationships they take up one to another.

This exhibition was curated by Fiona Bradley, Exhibitions Curator at Tate Gallery Liverpool, and organised by the Exhibitions department at the Gallery. We are grateful to Karsten Schubert and his staff in London for their help with the exhibition, and to all at Luhring

Augustine in New York. We are indebted to the institutions and individuals who have generously loaned works, and to the Henry Moore Foundation, which has supported the exhibition. We thank Rosalind Krauss, Bartomeu Marí, Stuart Morgan and Michael Tarantino for their contributions to this publication, and Elena Lledo for her assistance with it. Michael Tarantino is currently working with the artist and Alicia Chillida on an exhibition for the Museo Nacional Centro de Arte Reina Sofia, Palacio de Velázquez in Madrid in February 1997, and we are pleased to be able to collaborate with the Reina Sofia on the production of this publication.

Especial thanks go to Rachel Whiteread, who has given her time, energy and insight so generously to this project.

Nicholas Serota **Lewis Biggs**
Director Curator
Tate Gallery Tate Gallery Liverpool

Introduction

Fiona Bradley

Rachel Whiteread's sculptures solidify space. Casting directly from known, familiar objects, the artist makes manifest the spaces in, under, on or between things. Her casts, in plaster, rubber and resin, have a strongly material presence: they hold and occupy space, speaking to the viewer and to each other of the domestic landmarks of human experience. Central to her work, however, is that its materiality is also an index of absence. In the casting process the original, the recognisable object which the work seems to be 'about', is lost. What is left is a residue or reminder, a space of oscillation between presence and absence.

Whiteread has worked both inside and outside the space of a gallery, on a scale ranging from the very small – a hot water bottle, to the very large – a house. Wide-ranging though it is, however, her scale's constant reference is human, involved with objects that people can hold, use and inhabit. She speaks of a fascination with things which have been designed by humans for human use, and this fascination is embedded in her sculpture, conditioning both the making and the subsequent viewing of her work.

This publication accompanies two exhibitions of Whiteread's sculpture, in Liverpool and Madrid. The exhibitions present a domestic Whiteread, a furnished interior from which the larger scale, exterior projects – *House* and the forthcoming Holocaust Memorial for Judenplatz in Vienna – may be glimpsed. The publication extends the scope of the two exhibitions, moving outside the gallery both to consider the public impact of Whiteread's work, and to root this in the consistency of her practice. The book approaches Whiteread's work through words and images. Stuart Morgan links

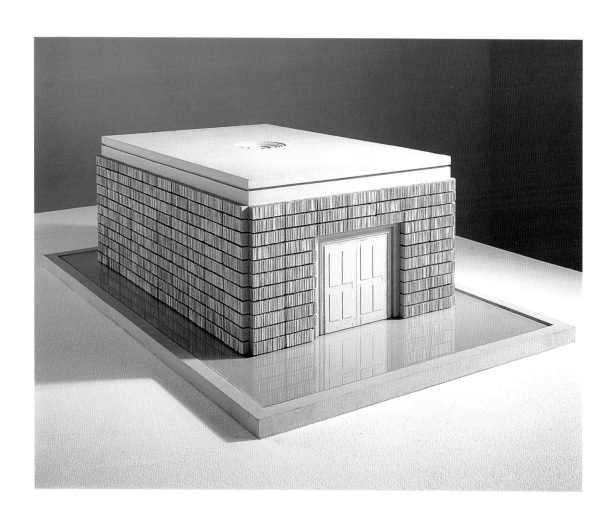

17 *Model for Judenplatz Holocaust Memorial* 1995

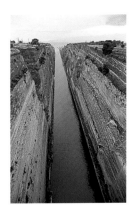

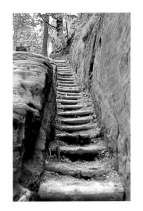

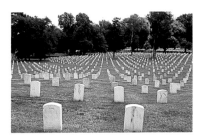

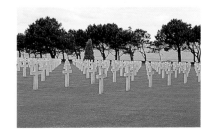

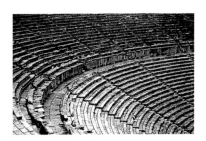

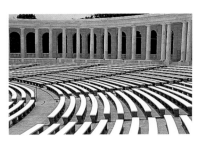

the sculpture, interior and exterior, to the specifics of post-war, urban London. Bartomeu Marí investigates monumentality as it is articulated by Whiteread through the site of the domestic. Rosalind Krauss assesses Whiteread's use of casting in the context of art history and theory. Michael Tarantino takes a sidelong, associative glance at the artist's simultaneous engagement with the visible and the invisible.

Whiteread's involvement with the built and manufactured environment involves her in the capture of space. Her particular, perhaps predatory approach to space is confirmed in the photographs she takes as part of her working practice. She photographs presences and absences: furniture abandoned on the street, bunkers, huts and houses, the space seemingly sliced out of the earth by the Corinthian Dam. She photographs structures fashioned to the dictates of the human body, which as you look at them tilt into palpable shape and pattern: the grids of buildings under construction or deconstruction, staircases, amphitheatres, stadiums, the organisation of identical graves in a war cemetery.

Photography, like casting, combines that which is present with that which is other – the residue of the original which advances and retreats in the mind of the viewer. In order to begin to understand the shapes of Whiteread's sculpture, a viewer might first relate them to the object from which they were cast. Faced by *Untitled (Bed)*, for example, we may mentally slot the legs of a bed into the four holes which puncture the sculpture, understanding the materiality of the sculpture in the gallery – a cast of the space underneath a bed – in terms of our experience of the object which inspired it. Memory of this object slips in and out of experience of the sculpture. Looking at Whiteread's sculpture entails a kind of mapping of the remembered on to the present. It involves the viewer in a relationship with the object from which the work was cast which both mimics and remains distinct from the relationship entered into

by the artist. Whiteread explores space. She finds out about it by filling it up, by putting it under pressure. Like looking at a photograph we can follow this process in our minds, but we remain external to it. Whiteread manipulates this sense of exclusion, using it to implicate us in the space with which she confronts us.

Take, for example, *Closet*, the earliest of Whiteread's exhibited sculptures. The exploration of the space inside a wardrobe, it is a solidification of this space, clad with a layer of black felt. *Closet*, like much of Whiteread's work, creates through destruction. It destroys a wardrobe (it was cast inside a wardrobe which was dismantled around it). It also destroys, by filling it, the space inside a wardrobe. The destruction of this space, of course, is what gives us back the wardrobe, both formally – the sculpture looks like a wardrobe – and conceptually – wardrobes exist in order to give us the space inside them, the space trapped by the sculpture.

Crucially, *Closet* shuts us out. In making the sculpture Whiteread has explored the space with which it deals, but we may not. Paradoxically, we are put in touch with the space by the elements of it that deny us entry: its solid mass, and its black surface. The sense of a palpable, black space in which one might hide as a child is re-imagined in the solidity of *Closet*, the layer of felt connecting the sculpture back to both the moment of remembering which inspired the work (Whiteread's own experience) and the object which gave it its form.

The surface of the sculpture provides the site of exchange between destruction and creation, the oscillation between what is known and what is other. It is this surface which locates the viewer in relation to the sculpture, physically and mentally. The detail of Whiteread's surfaces – the rust transferred on to *Untitled (Bath)*, the pattern of grooves left by the door of *Ghost* – helps to supply the viewer with the structures which gave them form. The surface of the sculpture is the point of contact between cast and original, but also

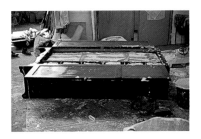 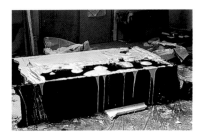

that between both cast and original and viewer: to understand the space we are looking at we have to become the place from which it came. We are the doors which left their imprint on *Closet* and *Ghost*; we occupy the bath whose surrounding space confronts us in *Untitled (Bath)*.

Whiteread has spoken about casting in terms of removing a surface from one thing and putting it on to another, of 'taking an image'. She has compared the process to the making of a death mask. In such a mask it is the surface which provides a key to the object's identity and, in doing so, involves the viewer in an imaginary assumption of that identity. Masks summon a human being because we can imagine that human being – a model of ourselves – putting them on. When you put on a mask, you occupy the place, the space, from which it was cast. The mask, while actually referring to the person for whom it was made, begins to refer to you. It does this even if you do not put it on: we recognise masks as representations of a face by imaginatively mapping the contours of its features on to our own. Remaining external to the actual mask, we place ourselves next to its inner surface. When a mask has been made by casting, this imagined proximity takes on an additional, and particular, resonance.

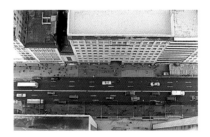

Rachel Whiteread's sculptures, by filling space, invite us to take up a mental position adjacent to that space, in the place of an original object which was initially designed with us in mind. The artist asks us to go back to beds from which we have risen, rooms we have left, chairs on which we have left our traces. Perhaps most poignant is *Untitled (Five Shelves)*, one of the most recent of Whiteread's exhibited works. The sculpture is a cast of the space around a set of bookshelves: it presents us with a small library of absent books. To make sense of the 'shelves', we must mentally replace the books and, in doing so, become entangled in the sequence of imaginative transactions through which the sculpture makes its meaning. Aside from Whiteread's treatment of them, books are in themselves the index of an absent presence. Reading a book entails the replacement of a material reality – the words on a page – with an imagined, perhaps remembered reality – what or where the book might be about. *Untitled (Five Shelves)* invites us imaginatively to hold – almost to be – something which is not really there. Books function in the same way. When we read a good book, it becomes part of us. While it may find a place on our bookshelves, the 'real' space it occupies is essentially internal.

Rachel Whiteread's is a consistent project. An early piece, made while still at art school, joined two chairs, one upside down above the other, with a column of seemingly solidified space, made from a blanket. The perceived solidity of the space prevented the viewer from occupying the chairs and, in doing so, forced the viewer who wished to understand the space mentally to become, in some strange way, one of the chairs. To relate to the space, we needed imaginatively to embody the place from which it came. Inevitably it came from an object which is itself an embodiment of, or a receptacle for ourselves. Whiteread's sculptures, slipping in and out of a relationship with 'real' objects from our experience and from our memory, give us back our own image. They symbolise objects which symbolise us.

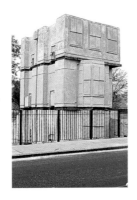

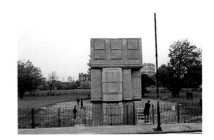

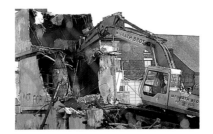

Rachel Whiteread

Stuart Morgan

By now the furore which accompanied the destruction of Rachel Whiteread's *House* has given way to a heightened awareness of the potential for monumental sculpture, its usefulness and relevance. Or irrelevance, for if sculptures acclaimed as significant can be destroyed like a bomb being detonated for the public good, this surely is a test of British education. Though the treatment of *House* was and remains a scandal, for Whiteread herself it will serve as a rehearsal for her forthcoming Holocaust memorial in Vienna, in the form of a library made of concrete, inside out as usual. By that time it will be possible to regard the case of *House* as only one aspect of the meaning of Whiteread's work in general, for now in particular it seems that the serenity of her sculpture is concealing a pact with the forces of violence. Isn't her method only one variant on evisceration, after all? For Whiteread's suave reversals fail to hide the fundamental gesture of her work: not, as has been argued, a series of fairy-story transformations but rather a set of manoeuvres more suited to a slaughter-house. In her work, sterility and silence serve as powerful reminders of the fate of the human body.

'Dematerialisation' was one term among many used in the 60s for the removal or replacement of the object in art. Henceforth, it seemed 'object' would be supplanted by its opposite, whatever that might prove to be. So a side-step would take place which would alter not the meaning of the object but rather shift its modality. The result resembled a kind of Mannerism, for levels of reality would be corrected, like a radio when its wavelength is altered. Beginning in the late 60s, Conceptualism of one kind or

another became the basis of thinking about advanced art. The result was a play with modifications of the viewer's perception. In the case of Rachel Whiteread, the restricted number and type of object that she has employed as a basis for her operations gives her work a philosophical turn, like examples returned to time and again in a lecture. And, as in any good lecture, those examples – a house, a floor, a bath, a sink, a bed, a mattress – became the basis of a set of mental operations that could be described as 'rematerialisation'. For traditional casting techniques allow her to present the object of her choice in exact scale but with disturbing revisions. Made in pieces, they need to be re-assembled, for example, meaning not only that separate parts of the object would be slightly different in colour or texture but also that imprecisions mattered: discolorations, for example, or gaps between one element and another. Sometimes slight revisions would take place. (*Untitled (Bath)* acquired a glass top.) But in general, the effect was of a sequence of subtle revisions that offered a means of gaining insights into the 'ordinary' and the overlooked.

A strong sense of history was present even at an early stage in Whiteread's career. Her first exhibition – in a window looking on to a nondescript North London street – consisted of Utility furniture filled with plaster. Behind glass the works looked angry, dadaistic: an attack on a society with the evidence of wartime austerity still embedded within it. Britain, it implied, was a country which had failed to get back on its feet, and which had simply been marking time since World War II, a war it had won but which had ruined it in the process. Neutralising objects of use was not Whiteread's aim. Instead, her act of sabotage was more profound: an attempt to annihilate meaning or to dramatise concealment itself. That this was a motive behind the sculpture became evident not long after, when more familiar spaces were cast: a bath, for example, or the area beneath a bed, a particular favourite of children, who seem

compelled to act and re-enact the myth of their own entrance into the world. A strong sense of interplay between separate sculptures became evident, as well as a physical vocabulary – hiding, sheltering, lying, satirising the grand gesture or monumentality in general – and a constant, if sepulchral, relation to the human body, which had remained so vulnerable for so long in the course of World War II. For if another powerful influence can be discerned in Whiteread's work, it is collections of casts such as those housed at the Sir John Soane Museum or the Victoria & Albert Museum in London.

Casting involves a turn of mind which is hard to explain. It could be best described as a sense of three-dimensional reversal. Whiteread is not the only contemporary sculptor to have chosen this method of working. (In 1965, for example, the American artist Bruce Nauman made *A Cast of the Space under My Chair*, and a year later *Shelf Sinking into Wall with Copper-Painted Plaster Casts of Spaces underneath*.) She may well be alone, however, in her degree of dedication to this particular mode of working. For her relationship with casting is not simply a bee in her bonnet. Nor is it an easy option; on the contrary, it represents a continuing attempt to create by concentrating on one method of operation, while shifting constantly from one material to another and registering the passage of time by deliberately working in series, one of the most important of those artistic procedures which have been our legacy from early Modernism. Despite this, strong parallels exist between traditional casting and Conceptual art. Whiteread's awareness of this fact separates the meaning of her casts from that of academicians, making her an avant-gardiste rather than a traditionalist. The rich dialogue that ensues between one piece and the next, a constant process of enriching her vocabulary and questioning the meaning of her own sculpture, distinguishes Whiteread's work, meditational and mundane in equal amounts.

Existing at a slight angle to the real, the sculptures force us to look more closely, for it is easier to tell that some alteration has taken place between the original object and what is made of it than to establish what exactly that alteration might have been. Sometimes it has to do with the material. (A bed, for example, which is meant to be soft, made in dental plaster, which is hard, or another mattress – propped against a wall as if a workman had used it to rest his legs at lunchtime – cast in rubber, meaning that in theory it could still be used as a bed and could bend, though just by looking it is hard to predict its consistency.) In the year before that, however, Whiteread had magnified a ceramic sink drainer, replicating it in marble at six times its normal scale, to end up with a slab resembling those found in mortuaries, with a space for the blood to drain away. Death was everywhere at this period of her work. The mattresses and slabs begin a conversation about the difference between resting temporarily and being 'At Rest' for good. Subtle comments on Minimalism can be discerned, yet such subtleties are overridden by the sheer oddness of some of the casts themselves: the table, for example (*Yellow Leaf* 1989) at which there is no legroom whatsoever, and another table of the same year aptly titled *Fort* because of its impregnability. One suggestion is of total exclusion, of there being no way in. Another is a version of a plan, in which distinctions between the separate elements of a whole – the gaps between the separate pieces of the cast – resemble architectural drawings. Oddest of all, perhaps, is a work made in 1990 called *False Door*, which, like a screen, has a back as well as a front. In other words, the viewer can walk around it and discover the extruded pattern of what would normally be inlaid, positive for negative, as if normal rules no longer apply. Yet the idea is not to lead the viewer into a phantom space; because of the casting technique, for example, the rust on the outside of a household bath can now be found on the 'interior' of the plaster version.

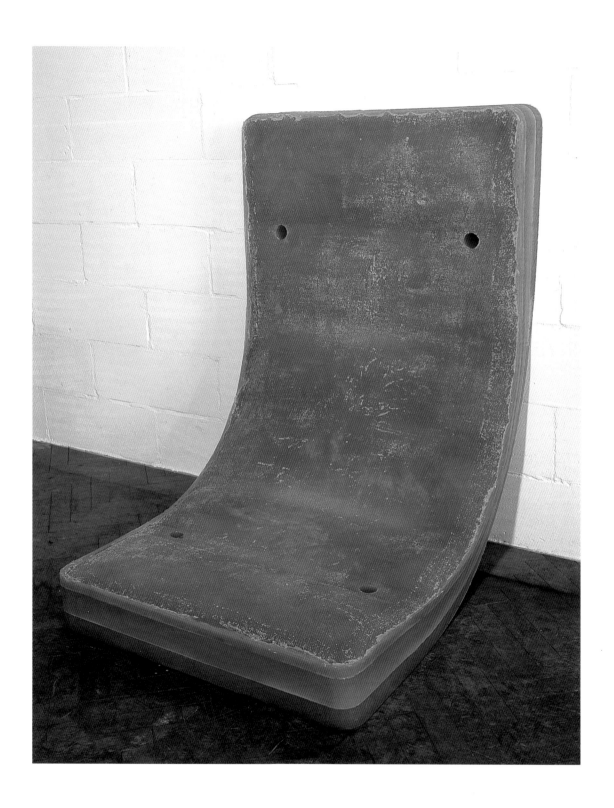

7 *Untitled (Amber Bed)* 1991

Other innovations involved the use of heavy, semi-transparent coloured elements, for example, which enabled the viewer to achieve partial vision. Yet none of these innovations turned out to be as remarkable and alarming as the reversals of the casting process itself. The last and most disturbing of these projects was *House*. In a part of London – the East End – in which such powerful feelings of belonging existed, the project, to cast an old house in its entirety, succeeded only too well. But problems were bound to arise; the choice of a house of a particular period was certain to bring back memories, not all of them pleasant: feelings of belonging and the constant challenges that entailed. (When pro-Nazi groups paraded through the area, for example, Jewish residents simply opened their windows and dropped their furniture on them.) For the building of *House*, Whiteread had to develop her technique, first of all to make the chosen house capable of being cast, secondly to plan and execute the scheme like a military operation. The result was haunting: one house left in what had been a street of identical houses. But by this time the noun 'house' scarcely applied. This was not in any way domestic, nor was it a place where people lived. In fact, it was an anti-house, inward-turning, speaking only of itself, on the one hand a parody of Modernist reflexivity, on the other a negative statement, banishing everything that a house means in order to summon even more fully the idea of a place to be: comforting, safe, above all a shelter and a sanctuary.

The major achievement of *House* was its ability to evoke interiority even as it seemed to banish every trace of inner life and meditation. The result was a monument which served to show how few monuments fulfil their true function: to call to mind, to pacify, to promote reverie, to act as a replacement, however wretched, for what has been lost. A point in time and space, it stopped visitors in their tracks to remind them of larger, deeper, simpler issues of life than their daily routine may include: issues they took for granted, in

this case the ideal not of a house as a building but of belonging in general. That the 'home' was now sealed and reversed might not have mattered. More poignant was its situation and its mere existence: as the last of a street, the reminder of a certain way of building but also of a study in closure, with all that that implies. The plight of the homeless in Britain can never be discussed enough, for it offers too little kudos for any political party seriously to engage with it. Artists, on the other hand, have no vested interest in keeping silent about injustice or poverty. A period, a way of living, family life, a community, a neighbourhood, a friendship ... To local residents, many of whom had lived in the area during wartime, *House* was the graveyard of all this: a sealed bunker like an overground vault, as well as an eyesore, a waste of space and money. In many respects they were not wrong, but the idea of monuments is to preserve certain issues in the mind, issues for which no easy resolution can be found. In other words, Whiteread's chosen task is to try to touch the collective consciousness.

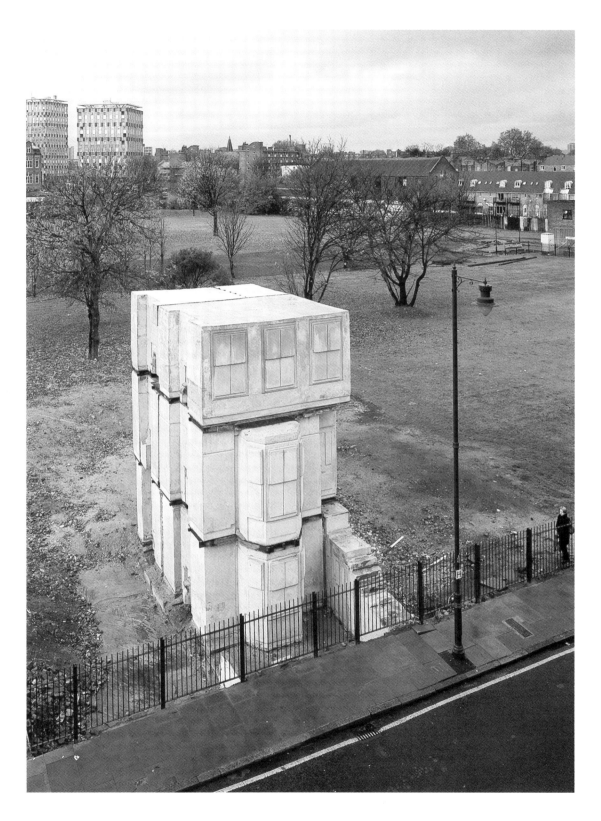

House 1993, commissioned by Artangel Trust and Beck's (corner of Grove Rd and Roman Rd, London E3, destroyed 1994). Photograph by John Davies

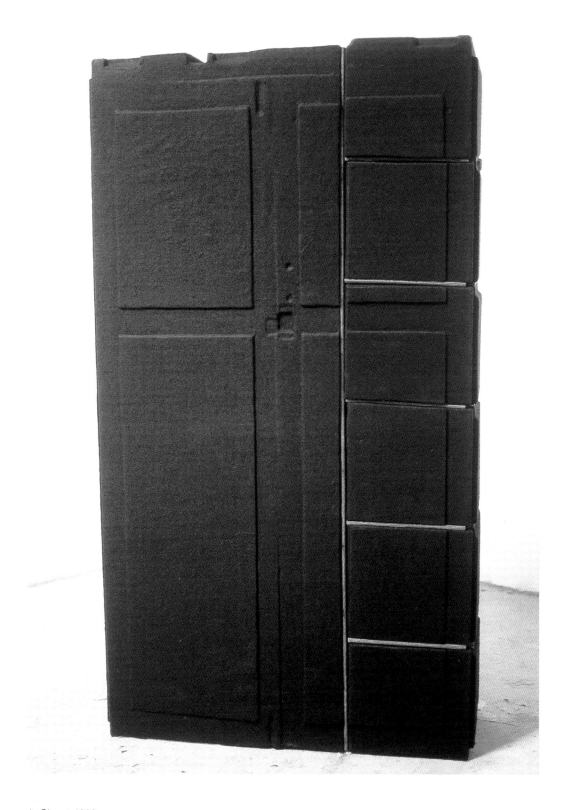

1 *Closet* 1988

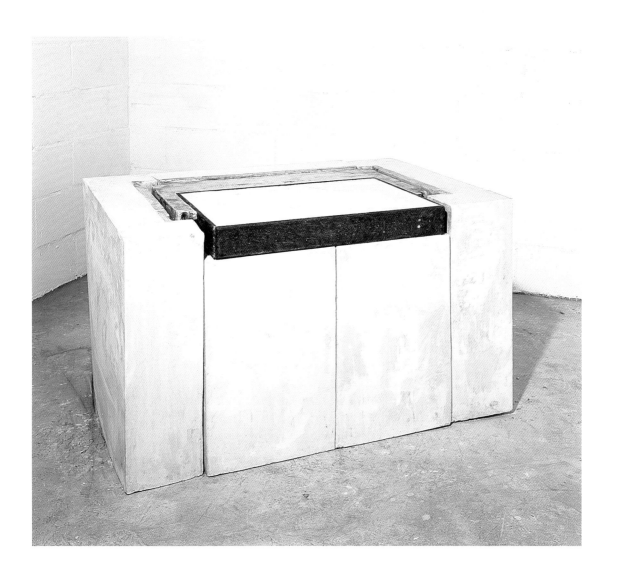

2 Fort 1989

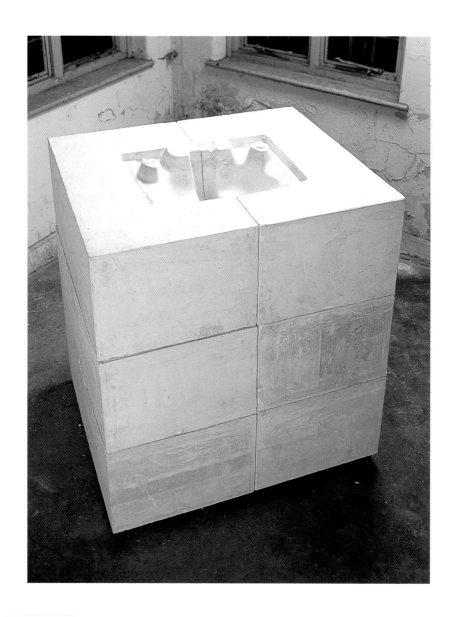

5 *Untitled (Square Sink)* 1990 4 *Untitled (Bath)* 1990

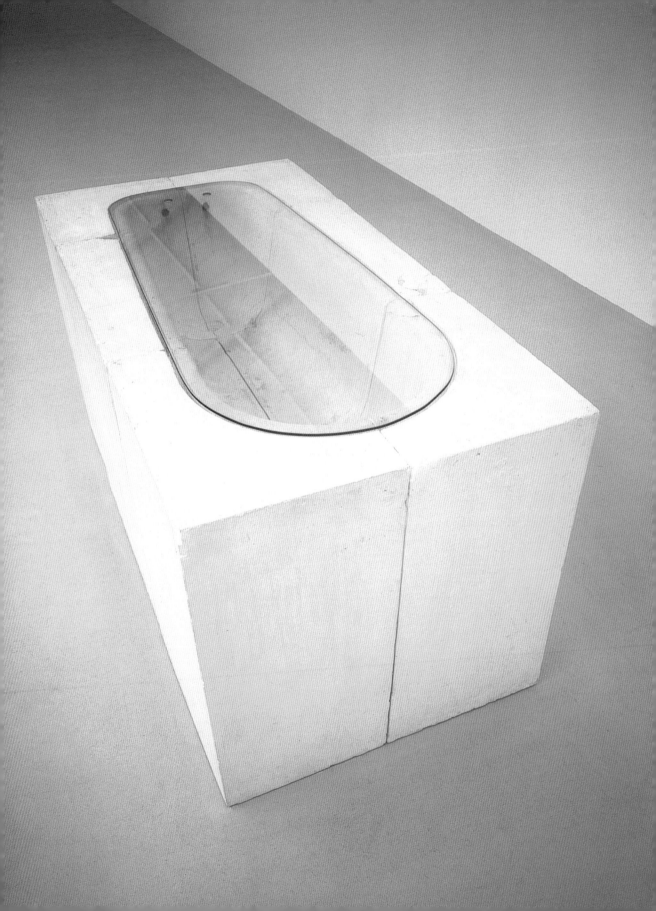

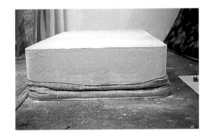

11 *Untitled (Grey Bed)* 1992

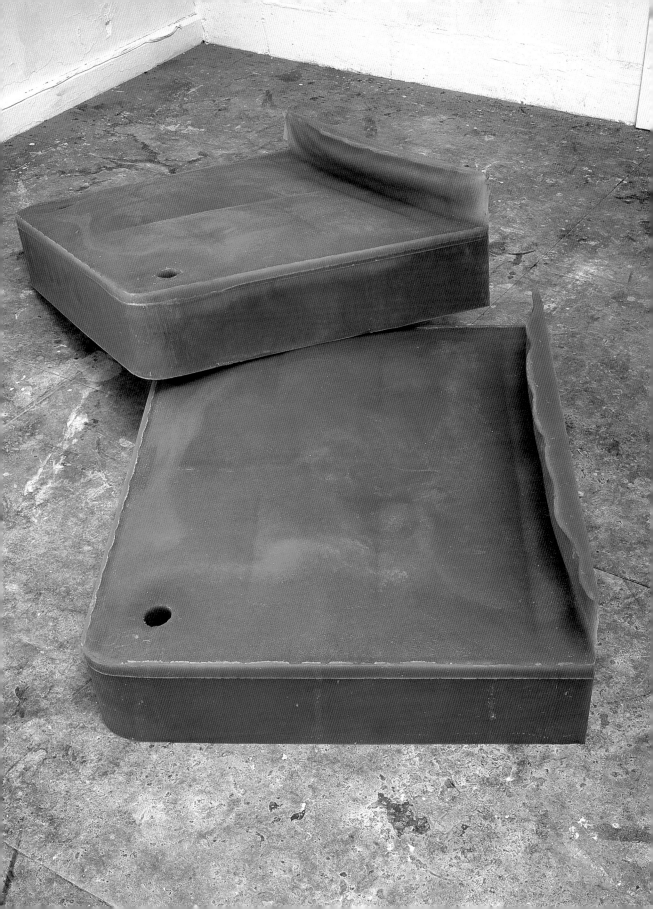

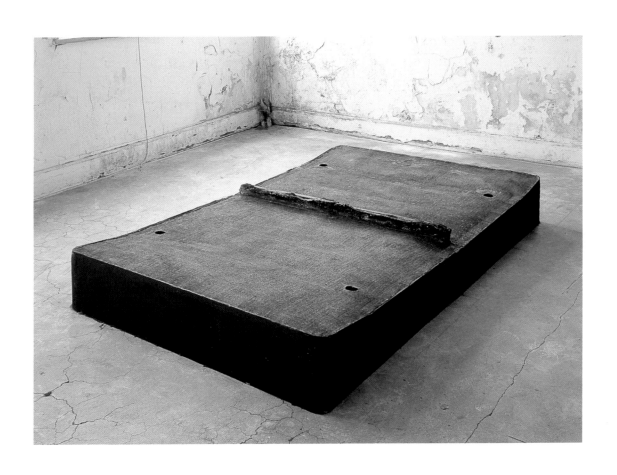

8 Untitled (Black Bed) 1991

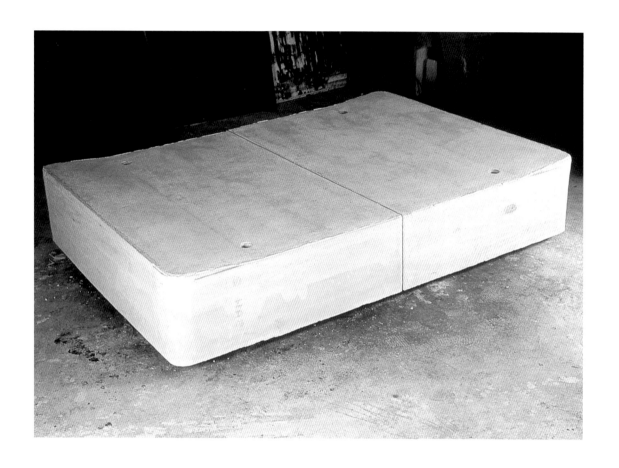

6 *Untitled* 1991

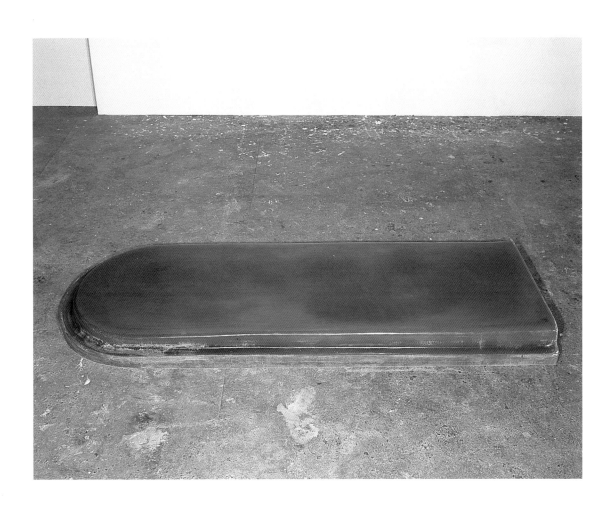

9 *Untitled (Slab II)* 1991

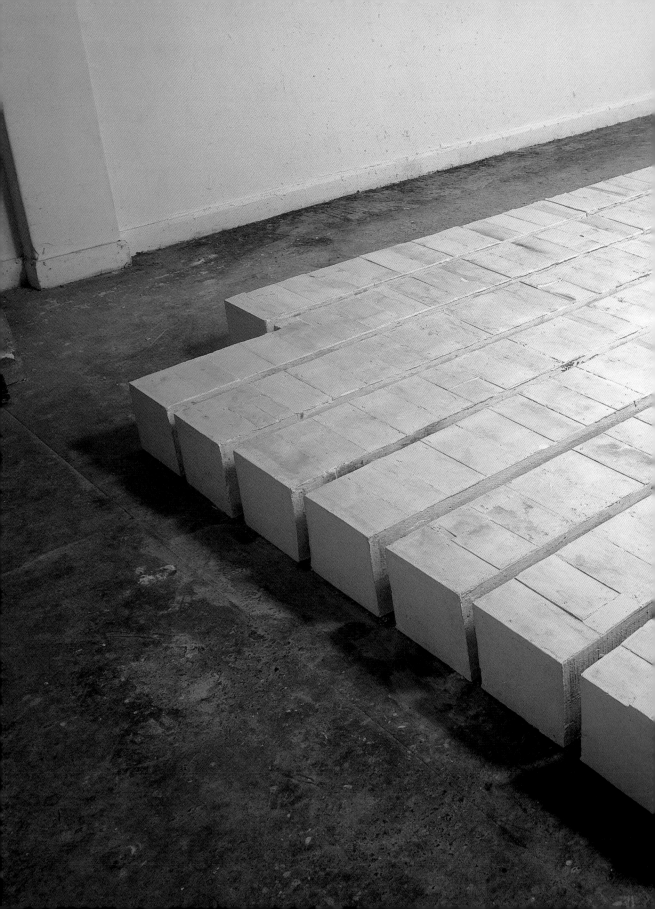

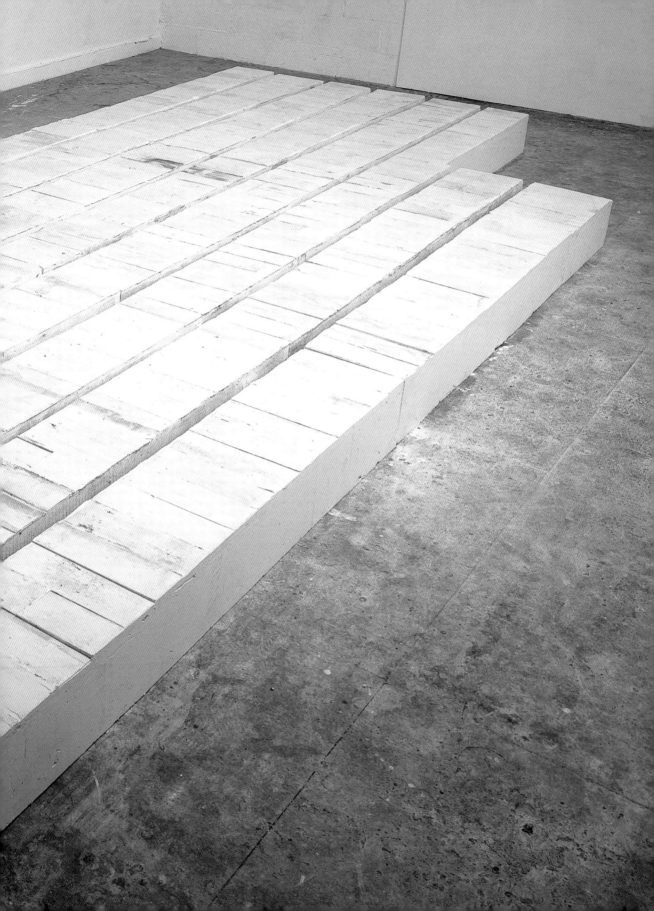

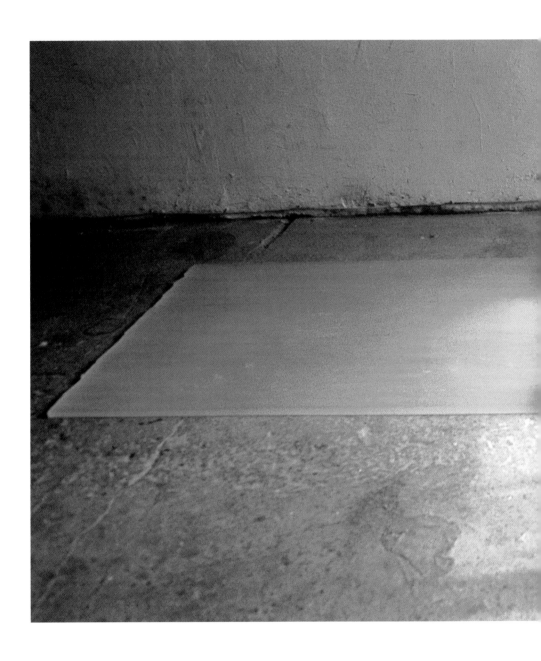

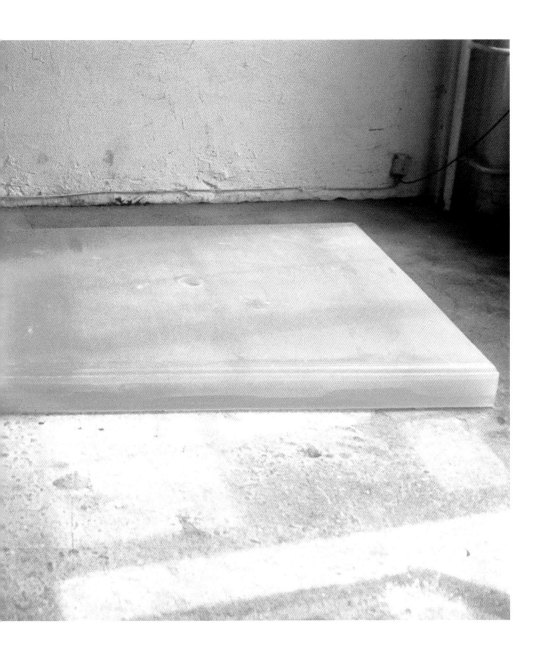

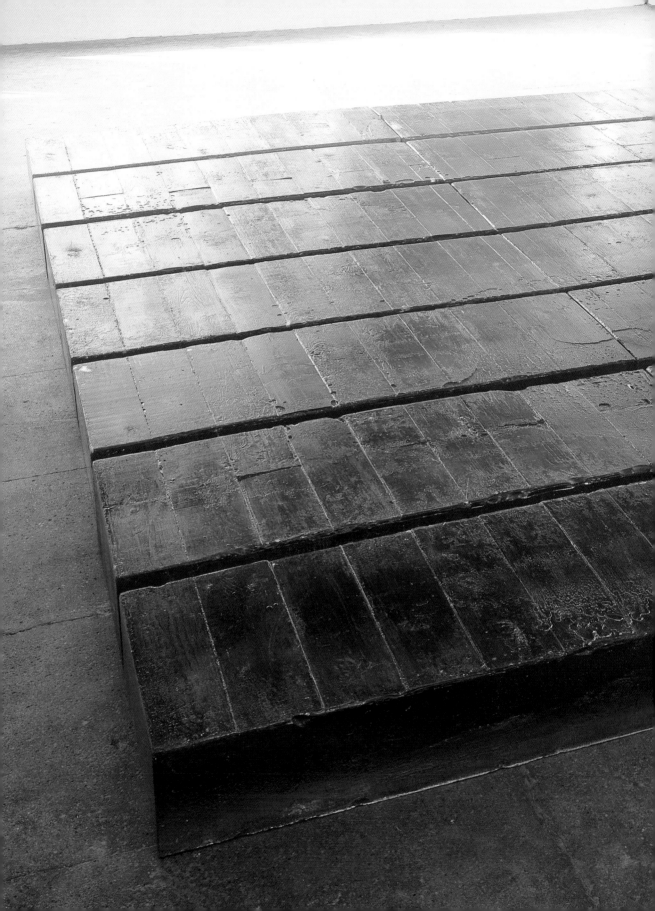

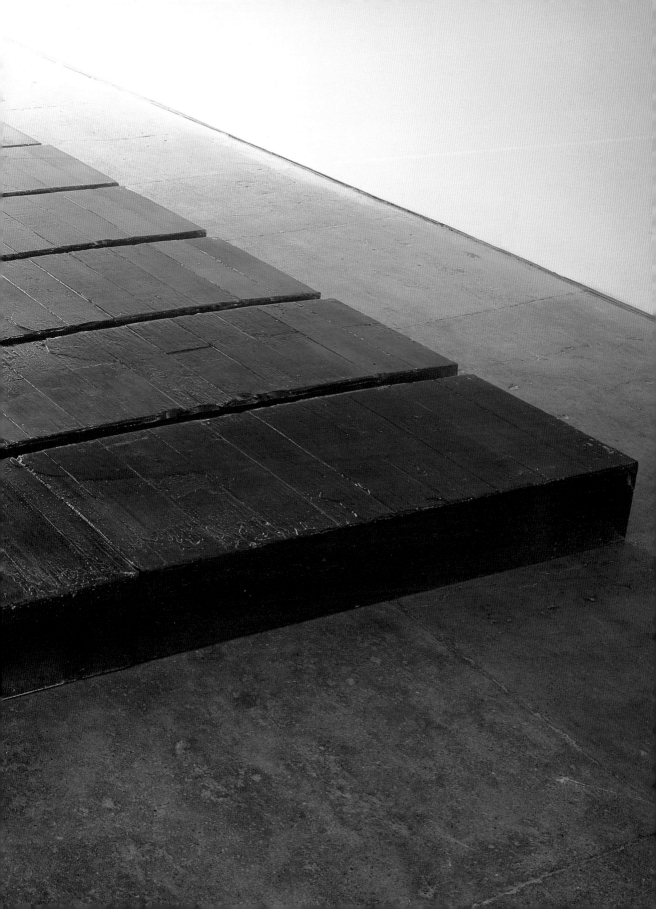

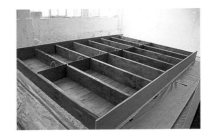

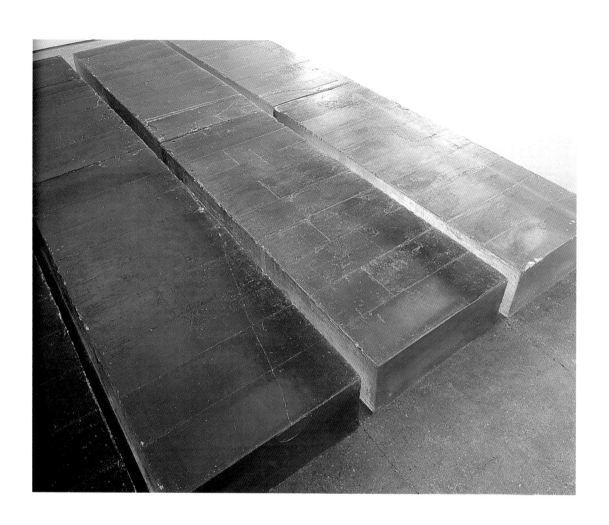

15 *Untitled (Floor)* 1994–95 (detail)

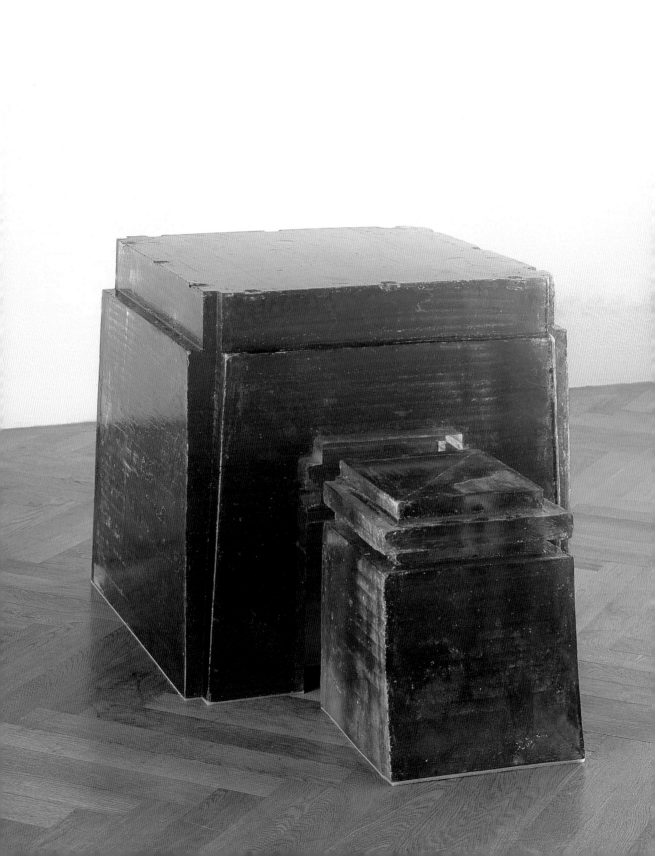

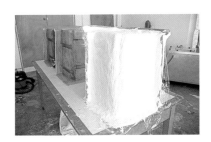
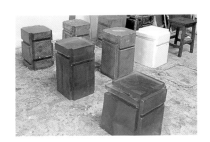
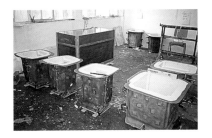
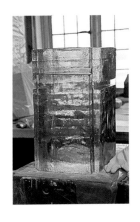

16 *Untitled (One Hundred Spaces)* 1995 (detail)

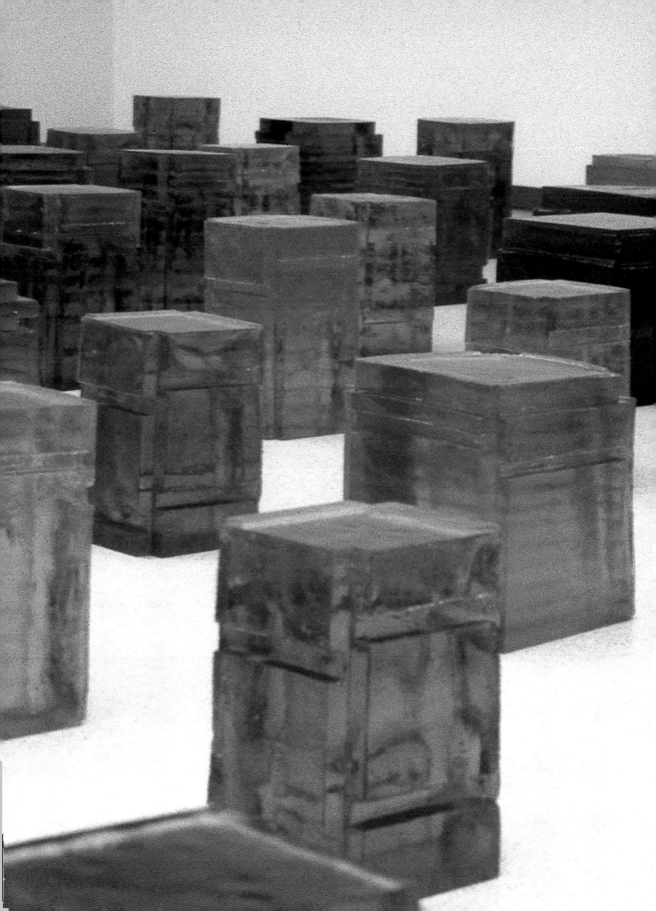

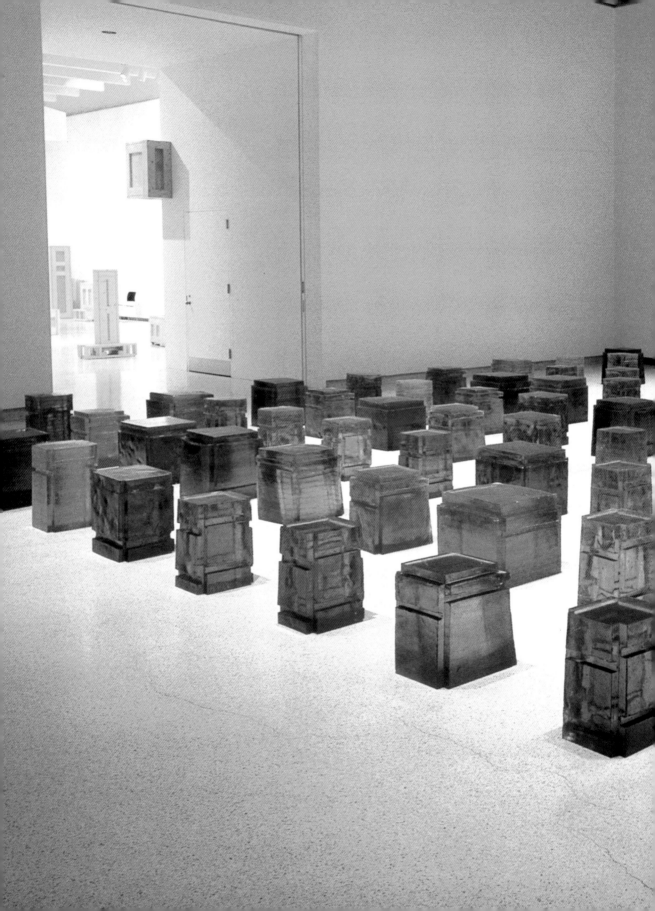

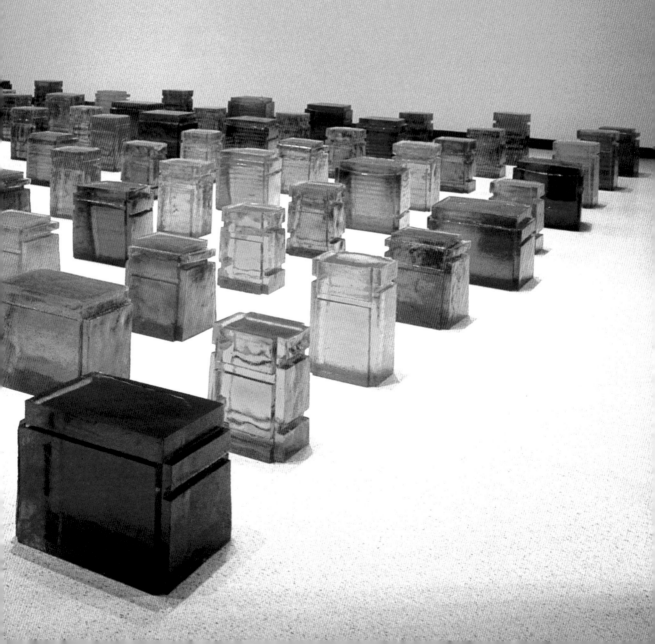

Previous page 16 *Untitled (One Hundred Spaces)* 1995

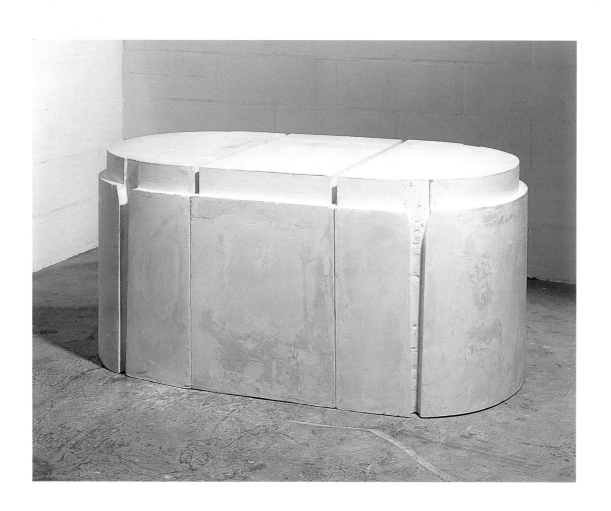

19 *Untitled (Plaster Table)* 1995–96

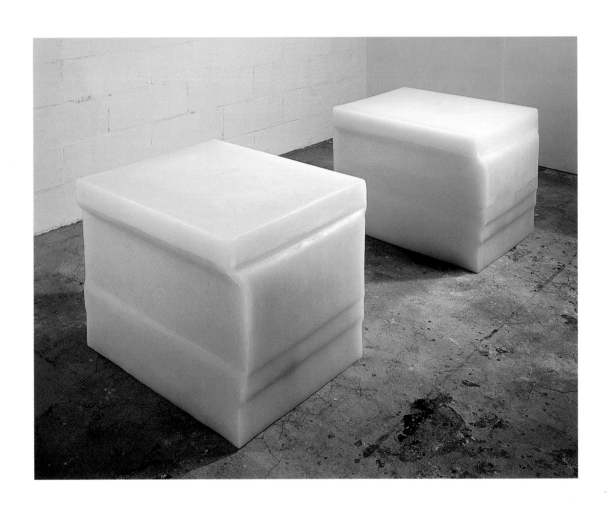

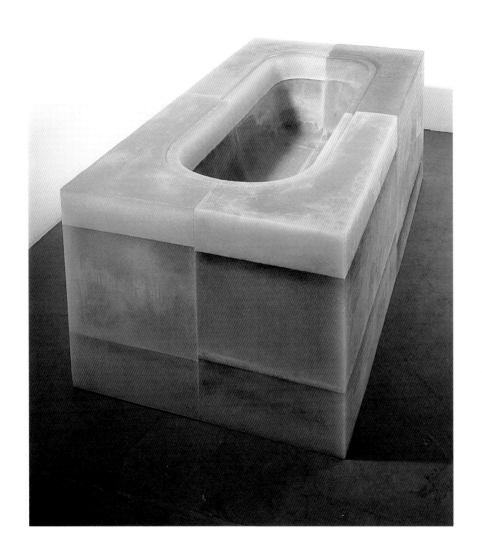

22 *Untitled (Orange Bath)* 1996

The Art of the Intangible

Bartomeu Marí

The work of Rachel Whiteread gives rise to many questions concerning the concepts and categories of contemporary sculpture. How do we, at the end of the twentieth century, decide that this or that object, charged with aesthetic intent, is 'sculpture'? Happily art, unlike mathematics, operates through intuition rather than definition. Rather than discussing the problems of definition raised by the work of Rachel Whiteread, therefore, I would like to share various intuitions about the work in relation to monumentality and the domestic sphere.

Rachel Whiteread's selection for the 1991 Turner Prize exhibition was the first time I had the opportunity to be surprised by what I considered her ironic and successful combination of particular Anglo-Saxon sculptural traditions (Minimalism and Pop Art) with the fundamentally classical, even ancient, technique of casting. Whiteread does not cast objects but the space they occupy, the space inside them, or the space they leave behind them as a trace – everything which is displaced from emptiness by matter:

> I simply found a wardrobe that was familiar, somehow rooted in my childhood. I stripped the interior to its bare minimum, turned it on its back, drilled some holes in the doors and filled it with plaster until it overflowed. After the curing process the wooden wardrobe was discarded and I was left with a perfect replica of the inside.[1]

The cast sculptures, in plaster, concrete, resin and rubber, are of very different natures and sizes. Focusing attention on the particularity of objects, they partake of a naturalism related both to the fictions of theories of physics which attach volume and mass to

the weight of things, and to the conventions of social space, defined as a relation between the public and the private. *Untitled (Square Sink)*, for example, materialises the projected volume between a sink and the floor, mapping for the viewer the trace left by the sink. The familiarity of the object, the idea of its everyday, intimate use, allows access to a universal language of private, basic, almost a-cultural functions. The object is personalised by this language, its connection with the private in direct contrast with the perceived public anonymity of architecture and constructed spaces.

Rachel Whiteread's sculpture connects public with private. The artist investigates the space of domesticity as a kind of personalised architecture, a space in which the building loses its anonymity and is forced to take on the position of protagonist. She has talked about buildings in human terms:

> The Slade and the surrounding buildings of the university had ventilator systems, an enormous array of pipes attached to them as though their internal organs were visible; there are offices in London that are out of commission because they have sick building syndrome. It's as if we are building these mausoleums for ourselves. We don't know how to deal with these buildings that are almost living and breathing, they have their own viruses: Legionnaire's Disease is transmitted through air conditioning systems. They are almost organic – you go into a building and it hums – it's the computer lines, the lights, the heating – this noise which sweeps into it.[2]

From Object to Building

Rachel Whiteread's sculptures take from architecture its intangible residues. Architecture is usually spoken of in terms of limits and

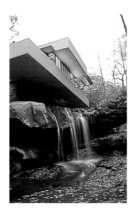

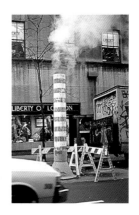

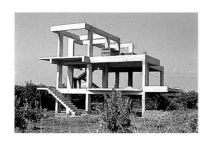

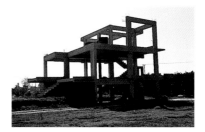

details, supports and superstructures, but this is not what is articulated by Whiteread's work. On the contrary, her work can be characterised as an attempt at 'engraving' the invisibility of architecture, materialising those traces and signs of identity which are largely ignored by both individual and society but are fundamental to irrational or intuitive perception.

In this light, two works appear particularly significant: *Ghost* and *House*. *Ghost* illuminates the nature of the sculptural object in a classical sense and consists of the cast of a whole room. The mass of plaster, 'taken out' of its real matrix, reconstructs, in negative, all the elements of the interior surfaces of the room: holes, dents, protuberances and irregularities which unfold on the visible surface of the object. This 'visible surface' is, I think, what turns the notion of 'negative' into something essentially uncanny, strange and unusual within the profound familiarity of the object it denotes. *Ghost* shares this familiarity with Whiteread's smaller-scale sculptures, cast from objects. These objects – mattresses, sinks, tables, chairs – are, like the room from which *Ghost* was cast, objects in touch with the human body and with the elemental functions of man as a living being: sleeping, washing, sitting, walking. They are commonplace, even banal – in life (like *Ghost*) and in art (unlike *Ghost*).

Ghost, like its counterpart, *Untitled (Room)* (cast from a fabricated, box-like Modernist room) presents the space of a room of specific proportions in another room, the room of the gallery. There is no play with scale or proportion. A full-size room is transported directly into another room and becomes an interior in the interior of another interior. Objects have a limited size, and we do not usually consider a room to be an object. Yet Whiteread handles *Ghost* (and in fact the even larger *House*) with the same technique that she uses for other, smaller objects. Her method of manufacture and presentation turns the architectural forms which are the source of *Ghost* and *House* into an extension of the personalised space of the domestic object.

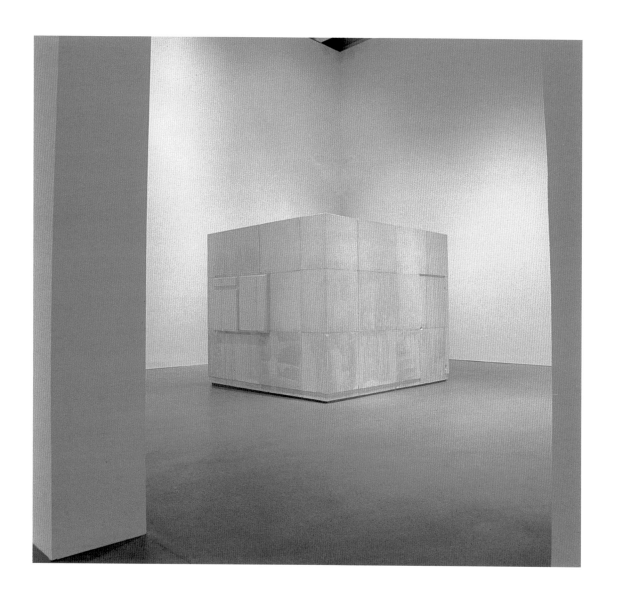

13 *Untitled (Room)* 1993

Domestic Phantom and Public Nightmare

In 1993 Rachel Whiteread made *House*, a cast of a Victorian terraced house situated in a typical East End London neighbourhood. The vicissitudes (bureaucratic and technical) of the work's construction have been examined in great detail in an accompanying publication, whose texts and photographs make a new description superfluous. The publication reunites the public, critical, architectural, technical and political debate instigated by the work which, together with its ultimate demolition, served to turn it into a minor myth. I did not have the chance to see *House*, experiencing it only through the media, and I feel that the work demonstrates the possibility of making a contemporary monument that uses a language which is both locally recognisable and at the same time universal.

There are two types of experience in architecture which are complementary but exclusive. The domestic experience, in which a precise and small scale predominates, and the urban experience, which is fundamentally monumental, even in those spheres articulated by the domestic (as in the case of many London neighbourhoods, such as the one in which *House* was cast, made up of an almost endless repetition of the same type of house). The European city developed from the centre outwards, an amalgamation of gradually inclusive units now classified by a hierarchical definition of space. *House* reflects some of the issues bound up with the evolution of such a city, and with life within it: the accidents of history, of real estate speculation, of gentrification. It raises more polemical issues in contemporary society: the right to have a home, control of property and the demise of areas of free access in the urban context.

It is in its engagement with these issues that *House* approaches the monumental. The most significant aspect of this reading of the

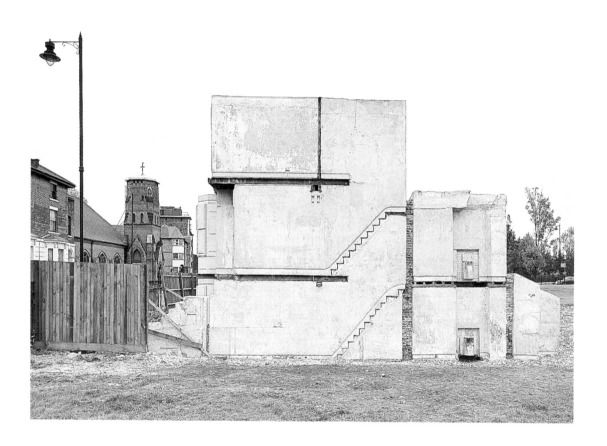

House 1993, photograph John Davies

work within the sculptural project of Rachel Whiteread is perhaps its availability for appropriation by anonymous scribblers. Monuments are signs of power, and elicit a response which can entail disrespect as much as respect. All public walls are susceptible to the scrawlings of individuals, and it is possible that anonymous graffiti constitute one of the simultaneously archaic and contemporary forms of the monument. Grafitti are an index of the intersection of public and private, a way of inscribing an architectural, monumental structure with the immediate concerns of an individual. They connect the grandeur and symbolism of the monument back to the small lives it seeks to memorialise. They form a universal language which replaces the domestic into the heart of the urban. In a society that defines itself as democratic, anybody with something to say only needs a wall to make it known to others.

Memory and Monument

This year Rachel Whiteread has been awarded a public commission of great significance and symbolic importance: to design a Holocaust memorial to be erected in Judenplatz, Vienna. The tradition of the memorial is specific to the Jewish culture in which it is practised very frequently. The Christian tradition confines the commemoration of the dead or of tragic events to anniversaries. The Jewish culture extends this to more everyday manifestations of remembrance.

Rachel Whiteread proposes for this monument (and I would like to distinguish between the notion of the 'memorial', the constant impulse to remembrance, and the monument, a manifestation of it) the cast of the interior of a library to be placed in the centre of a square of traditional character and modest dimensions. The casting of this library will be done from its interior, that is that part which is invisible in the room itself. Instead of the spines of the

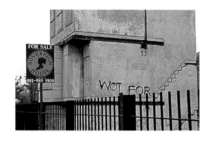

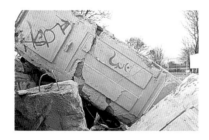

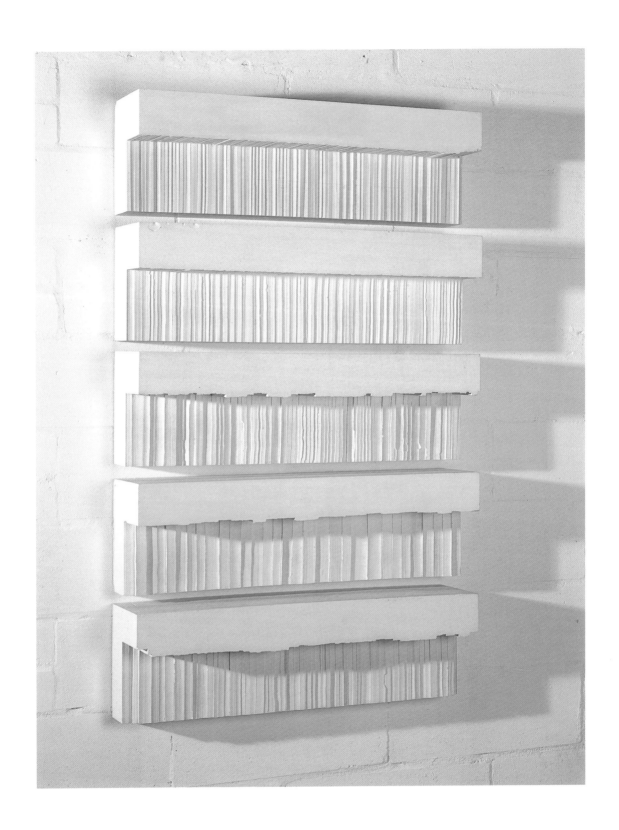

18 *Untitled (Five Shelves)* 1995–96

books, Whiteread's library will present their pages, together with the space that remains between the books and the backs of the shelves. The maquette of the work may remind us of a kind of small Egyptian temple, with no attributes except the very fine edges of the pages pointing outwards into the square. (It is important to remember here that, in the moment of the creation of the State of Israel in 1948, a discussion took place about the nature of remembrance and commemoration of the Holocaust, which defined the subject of, and the necessity for, a memorial. The discussion was about whether to erect monuments to the missing people or to remember them through the publication of books which would become part of libraries, remaining in the domestic sphere. The latter option was the one chosen by Ben Gurion, then Head of State).

A library is the materialisation of knowledge; histories and experiences which, condensed in books, belong as much to the domestic sphere as to that which is publicly accessible. Every library is both a monument and a memorial. With Rachel Whiteread's 'library', again we find ourselves confronted with the negative of some volume and its inverted image (something which has been observed from the interior to its perimeter, rearranged so that it is seen from the exterior to the limit of vision). All this has the unexpected and almost obscene quality of that which is not supposed to be seen.

One of the greatest impediments to the construction of a contemporary monumental language is the rejection by modern artists of the logic of the monument or its transformation. Without entering into the definition of this logic, the situation of urban art due to real estate speculation has silenced the language of public memory in favour of the uproar of propaganda. It may be that Rachel Whiteread only constructs walls for others to stamp with their scribbles, their personal commemorations. Even if this is so, I am still convinced that this is one of the basic forms of

commemoration. Fundamentally irrational, the monument as a category functions as much visually as unconsciously and it is the product of violence. Or as the sculptor herself puts it: 'Obsessive or compulsive disorders, completely irrational activities, the psychology of violence [...] it's a dark area of human unconsciousness that no-one can unlock, something we will never fully understand.'[3]

1. The artist discussing the making of *Closet*, in 'Mute Tumults of Memory', *Rachel Whiteread: Skulpturen/Sculptures* (exh. cat.), Kunsthalle Basel, ICA Philadelphia, ICA Boston, 1995, p.12
2. 'Rachel Whiteread in Conversation with Iwona Blazwick', *Rachel Whiteread* (exh. cat.), Stedelijk Van Abbemuseum, Eindhoven, 1993, p.12.
3. Ibid., pp.14–15

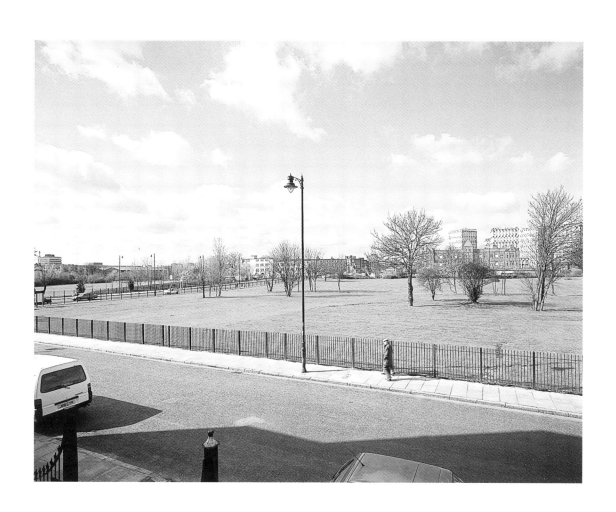

House 1993, photograph John Davies

X Marks the Spot

Rosalind Krauss

Sometime in 1965 Bruce Nauman made a plaster cast of the space under his chair. Perhaps it was late in the year, after Donald Judd's 'Specific Objects' essay had appeared, or perhaps earlier, for example in February, in relation to Judd's review of Robert Morris's Green Gallery exhibition, or in October, after Barbara Rose had published 'ABC Art', her own bid to theorise Minimalism.[1] In any event, Nauman's cast, taking the by-then recognisable shape of a Minimalist sculpture, whether by Morris or Tony Smith, or Judd himself, was more or less cubic, greyish in colour, simple in texture ... which made it no less the complete anti-Minimalist object.

Several years later, when the tide against Minimalism had turned and the attack on Minimalism's industrial metaphor – its conviction in the well-built object, its display of rational tectonics and material strength – was in full swing, this reaction would move under the banner of 'Anti-Form', which is to say a set of strategies to shatter the constructed object and disburse its fragments.[2] But Nauman's cast, which he repeated the following year in two other forays – *Shelf Sinking into Wall with Copper-Painted Plaster Casts of Spaces underneath* (1966) and *Platform Made up of the Space between Two Rectilinear Boxes on the Floor* (1966) – acting well before anti-form, does not take this route of explosion, or dismemberment, or dissemination. It does not open the closed form of the fabricated object to release its material components from the corset of their construction, to turn them over to the forces of nature – gravity, wind, erosion – which would give them quite another articulation, one cast in the shadow of natural processes of change. Rather, it takes the path of implosion or congealing, and the thing to which it

submits this stranglehold of immobility is not matter, but what vehiculates and subtends it: space itself.

Nauman's attack, far more deadly than anti-form – because it is about a cooling from which nothing will be able to extricate itself in the guise of whatever articulation – is an attack made in the very name of death or, to use another term, entropy. And for this reason, the ambiguity that grips these residues of Nauman's casts of interstitial space, the sense, that is, that they are object-like, but that without the title attached to them like an absurd label, one has no idea of what they *are*, even of what general species of object they might belong to, seems particularly fitting. It is as though the congealing of space into this rigidly entropic condition also strips it of any means of being 'like' anything. If the constant utilitarian character of Minimalist objects – they are 'like' boxes, benches portals, etc – or the more evocative turn of process works, continued to operate along the condition of form, which is that, having an identity, it be meaningful, it is the ultimate character of entropy, Nauman's casts force us to realise, that it congeals the possibilities of meaning as well.

More than two decades later, Rachel Whiteread would return to this terrain suggested by Nauman's casts, but do so quite apart from the baffling refusal of Nauman's residues to manifest their 'identities'. Her own homage to Nauman – her cast resin *Table and Chair (Clear)* – places the two masses in a juxtaposition that makes perfectly evident what objects had shaped them, which is true as well of the mortuary tables, bathtubs, mattresses, and ultimately rooms, of which her casts are the moulded results. So that in contradistinction to a vision of entropy that sees it as sucking out all the intervals 'between' points of space, so that not only the 'Brownian movement' of a molecular agitation is slowed to a stop, but also the distances that regulate the grid of oppositional differences necessary to the production of meaning are eradicated.

Whiteread continues to work the grid of signification. It's what she does to this grid that ultimately returns her work to the domain of entropy.

Content to register the identity of the object that served as the mould for her casts, indeed to heighten this through a careful attention to surface detail, Whiteread's work self-evidently attaches itself (unlike Nauman's) to the whole array of indexically produced forms that extends from death masks to photographs, all of these extremely resonant with the sense that they have been cast (whether physically or optically) from 'life'. And like the death mask and the photograph – at least the photograph as Barthes has wanted to consider it – this work is continually moving through a funerary terrain, a necropolis of abandoned mattresses, mortuary slabs, hospital accoutrements (basins, hot-water bottles), condemned houses.

Indeed Barthes has already written the outlines of a critical text on Whiteread's art, in his own consideration of photography as a kind of traumatic death mask which is paradoxically both 'structured' (thus constructed in terms of the paradigms or oppositions that undergird semiosis) and 'asymbolic', a paradox that leads Barthes to say in the face of photography, 'I have no other resource than this *irony*: to speak of the "nothing to say"'.[3] So that when he refers to all those photographers rushing around in an effort to capture reality as being 'agents of Death', this association is given its point by the further consideration of how death could possibly fit in a society without ritual, without rites, without religion, which is to say a culture gripped by modernity. 'Instead of constantly relocating the advent of Photography in its social and economic context', he urges, 'we should also enquire as to the anthropological place of Death and of the new image. For Death must be somewhere in a society; if it is no longer (or less intensely) in religion, it must be elsewhere; perhaps in this image which produces Death while trying to preserve life.'[4]

Photography's 'this-has-been', its essence understood as 'the living image of a dead thing',[5] its separation of life (the object posing) from death (the pose as past – what Barthes calls 'the mortiferous layer of the Pose',[6] along the instantaneous open-and-closing of the shutter, produces the spacing, or the oppositional structure of a paradigm. But unlike the paradigms that formalise ritual in all their symbolic elaboration, in all their recourse to myth, to rhythmic organisation, it is, he says, a 'a kind of abrupt dive into literal Death. *Life/Death*: the paradigm is reduced to a simple click, the one separating the initial pose from the final print'.[7]

This is what guarantees the 'nothing to say', which is to say the asymbolic condition. It is a 'flat death', which 'I contemplate without ever being able to get to the heart of it, to transform it'.[8] It thus gives me the intense actuality of matter placed precisely beyond what Bataille had attacked as 'the play of transpositions' which is to say of base materialism.

Indeed, it is within this context of the *asymbolic* that Whiteread's use of casting material takes on its particular, entropic sense. For the various materials she employs, from transparent resins to opaque plaster to translucent rubber, take on the quality of having solidified what had formerly been an articulated structure – the mattress's network of springs, for example – into a coagulated mass, undifferentiated, flat, but separated by the 'mortiferous layer' of its surface, from the living context in which we find it: life/death.

And there is a further aspect of this paradox of the asymbolic paradigm at work in her particular relation to casting, namely the recourse to architectural scale objects, such as *Ghost* and *Untitled (Room)* (as well as the now-demolished *House*). These strange carcasses of actual sites, cast in place, take on another character of the coagulation of the paradigm. For their specificity works against the habitual activity of casting, whether within an aesthetic or industrial context, which is to make serial runs of objects, to spin

out multiple copies. Working against the grain of the multiple, these casts instead have the character of the absolute particular of something unique, which had existed in a specific place, and to which this now mutely points: *X Marks the Spot*, as the title of a book on criminal deaths, reviewed briefly by Bataille,[9] put it – the trace of a contingent 'this'.

It is not, of course, that *Ghost* 'marks the spot' of the room from which it was cast in the actual place of its making. Like the life-size plaster casts of Romanesque portals or Gothic choir stalls on view in the Museum of French Monuments, these are plaster casts that are stuck in a posture of referring to the spot where the real thing existed in all its particularity. They do not pretend to have the 'repleteness' of a work of art. Instead of this autonomy, they are signposts pointing elsewhere, to an elsewhere before the object has entered the museum, to the elsewhere where they might have had a ritual or cult or specific political value before they had entered the system of sign-exchange value that grips the objects in the modern museum. As Denis Hollier has written of the objects that were housed in the former Trocadero museum, with its ethnographic displays on one side and its French monuments on the other: 'An identical resistance to the laws of exchange- and exhibition-value leads ethnography and aesthetic reflection to the same demand for the irreplaceable, to the same longing for a world subject to the tyranny of use-value. The "particular" refers here to the inexchangeable heterogeneity of a real, to an irreducible kernel of resistance to any kind of transposition, of substitution, a real which does not yield to a metaphor.'[10]

In this age of the multiple, two types of fate lie in wait for the site-specific object, two types of decontextualisation. Either it enters the museum stripped of all reference to its original context, a newly wrought autonomous object which, like a newly minted coin, circulates freely within the aesthetic system as an increasingly

weightless sign; or in Disneyland fashion, it settles into a condition as spectacle erected on a site displaced from what might have been its 'origin' but to which it now, gaudily parading another type of purported symbolic completeness, is unconcerned to refer. In contradistinction to these two forms of articulation, however, the monochrome plaster of Whiteread's casts announce their own insufficiency, their status as 'ghosts'. And it is by courting this very incompleteness that, without pretending that cult value can ever be recaptured in this post- 'auratic' age, the multiple form of these mammoth replicas nevertheless loses its inherently serial nature to take on the particularity of that kind of index that is caught at the heel by the object from which it is cast.

1 Donald Judd, 'Specific Objects', *Arts Yearbook*, VII (1965); Judd 'Reviews' *Arts*, (February 1965); Barbara Rose, 'ABC Art', *Art in America*, (October, 1965).
2 Robert Morris, 'Anti-Form', *Artforum*, Vol. 6 (April 1968), pp 33-35; reprinted in, *Continuous Project, Altered Daily: The Writings of Robert Morris*, Cambridge, Mass., MIT Press, 1993.
3 Roland Barthes, *Camera Lucida*, trans., Richard Howard, London, 1982, section 38, p 93.
4 Ibid., p 92.
5 Ibid., section 33, p 79.
6 Ibid., section 5, p 32.
7 Ibid., section 38, p 92.
8 Ibid., p 93.
9 Bataille, 'X Marks the Spot', *Documents 2*, no.8 (1930), p 437.
10 Denis Hollier, 'The Use-Value of the Impossible', *October*, no.60 (Spring 1992), p 11.

Next page House 1993, photograph John Davies

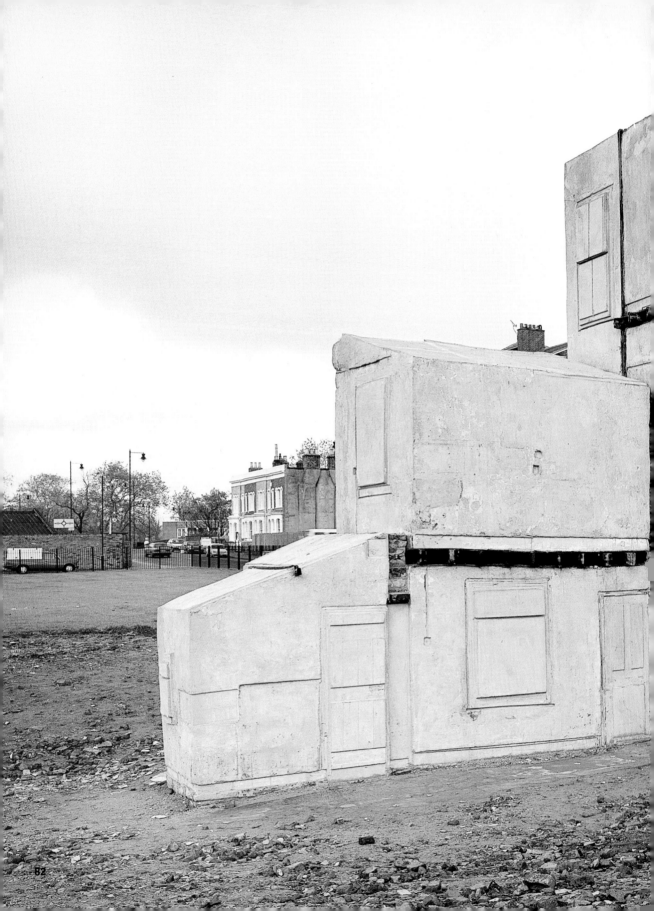

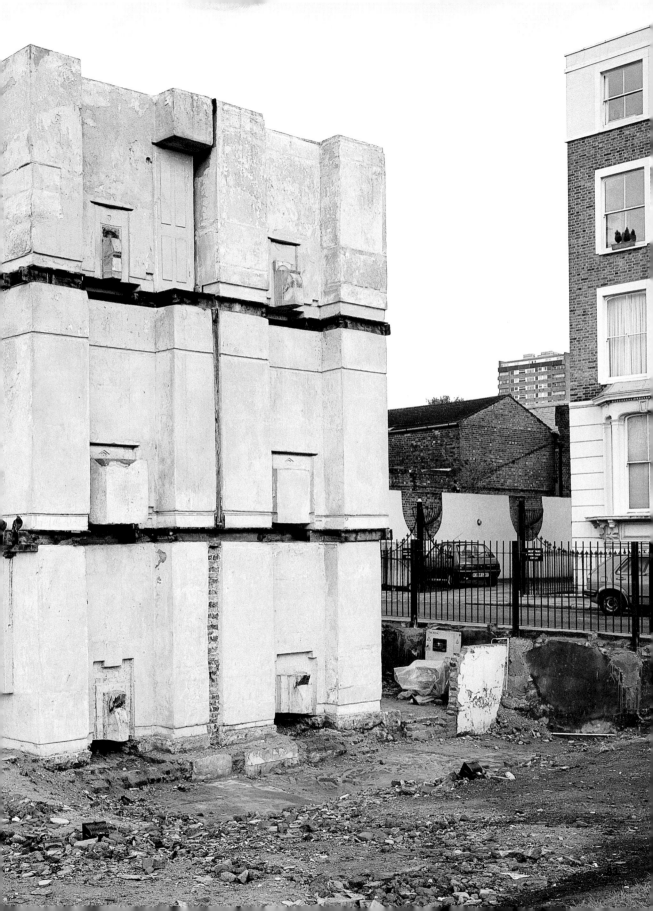

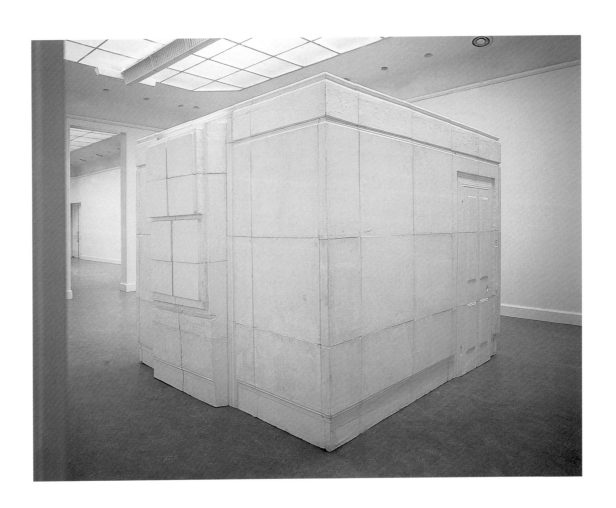

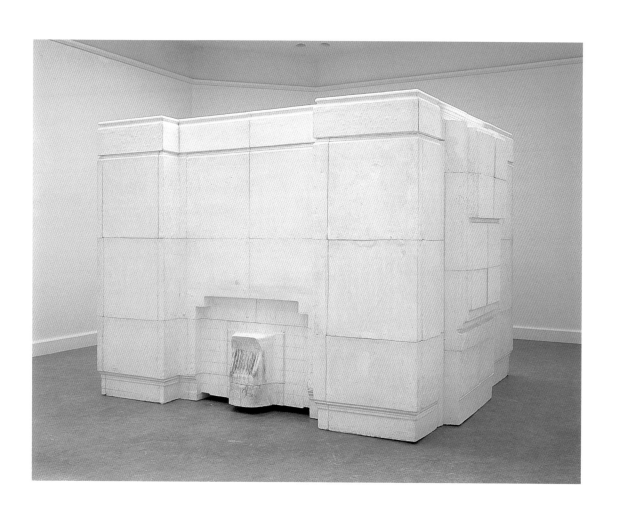

3 *Ghost* 1990

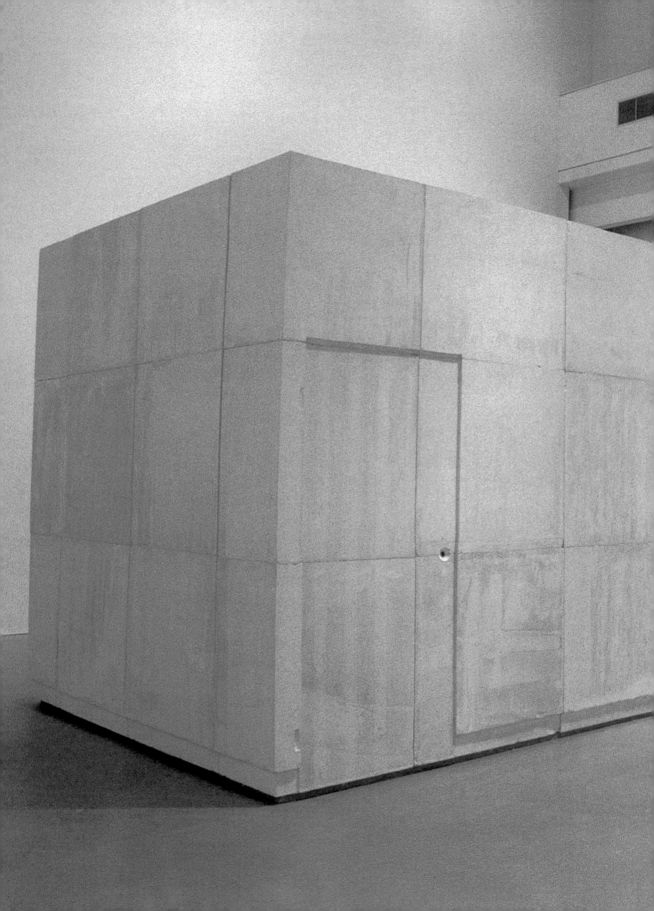

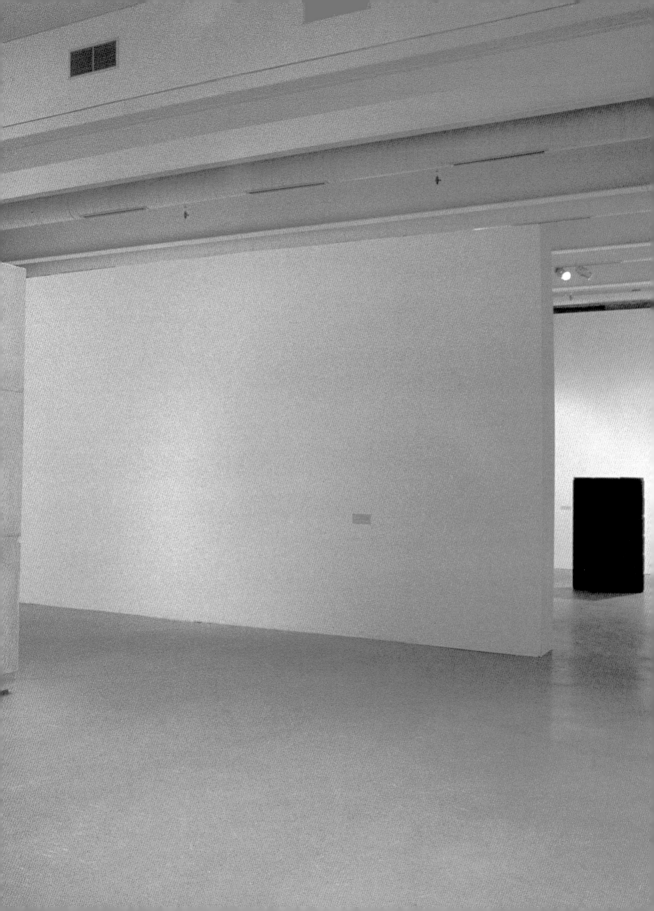

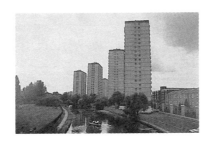

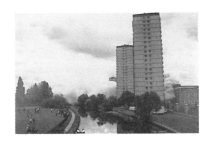

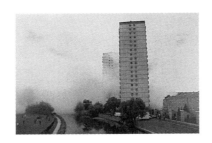

20 Prints from *Demolished* 1996

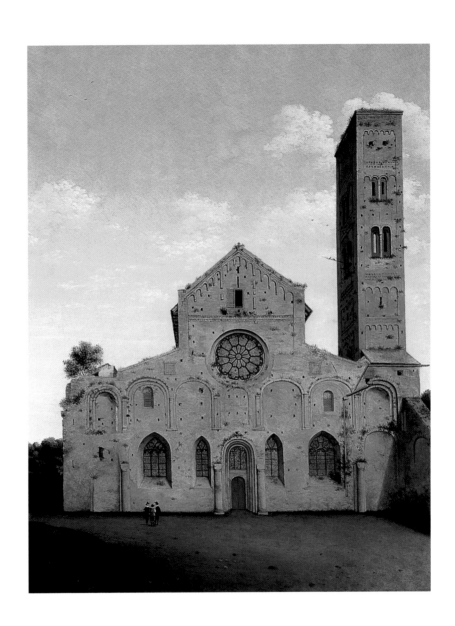

Façade of the Mariakerk, Utrecht 1662, Pieter Saenredam

The Space between Things

Michael Tarantino

I. Façade of the Mariakerk, Utrecht, 1662

The painting is by Pieter Saenredam. It is, at first glance, a remarkably uncomplicated image, characterised by a sober, almost brutally frontal view of a Romanesque church. It occupies a middle ground position, far enough away for us to see (almost) the entire façade, close enough for us to notice individual details. It is punctuated by foliage: in the left foreground is a mound of grass; behind the church is a grove of trees, which may be briefly glimpsed again on the other side; another tree is growing out of the building itself, on the upper left hand side. Low-hanging clouds dot the sky, with the occasional group of birds visible. Three figures stand outside the church, conversing. Etc. In short, it is a precise architectural record of a building and a serviceable Dutch genre painting, effecting a unity of three elements (nature, people and buildings).

Not surprisingly, it turns out that the 'purity' of the view, the lack of impediments that would somehow turn our attention away from the façade, is an elaborate construction on the part of Saenredam. For instance, the town of Utrecht, which could be seen by anyone approaching the church, is completely invisible in this rendering. Any glimpse of the city that might be perceived is hidden behind the church itself and the greenery. The road that takes up the foreground further isolates the façade as the sole object of our contemplation. The inescapable result is that the church completely dominates the space before us.

The three men in front of the church are also elements in the artist's attempt to focus our view on the façade. They are there to

emphasise its height, to give us a contrast in scale. Any attempt to impose a narrative on to the presence of these three figures is doomed by the absence of distinguishing characteristics or gestures. They are figures in a landscape – nothing more, nothing less.

The absences that mark this painting – in particular, geography and narrative – thus create a presence which seems at once contemporary and historically rooted. For if the rendering of the façade creates a space in which all lines are drawn to the rosette window in the centre, it also functions as an architectural record of a building which is in the process of becoming a ruin, an emblem of the past. The tree growing out of the left corner, the walled-up windows, the general absence of activity: these point to a site which has outlived its purpose. What Saenredam shows us is a dead space, a space in which what lies behind the façade probably belies the symmetry at the front.

In his article in the catalogue *Perspectives: Saenredam and the Architectural Painters of the 17th century*, Jeroen Giltaij notes that the term 'perspective' was used in the 17th century to refer to paintings of architectural subjects: in the case of Saenredam, 'churches, halls, galleries and buildings'. Furthermore, if we look to the dictionary to define the term more closely, we find two particularly relevant meanings: '1) A way of regarding situations, facts, etc. and judging their relative importance. 2) The theory or art of suggesting three dimensions on a two-dimensional surface in order to re-create the appearance and spatial relationships that objects or a scene in recession present to the eye' (Collins English Dictionary).

Thus, Saenredam's painting is a 'perspective' in two senses: in the sense that it marks the point of view of the spectator, the position from which he/she views the subject and in the way that it represents space. In both cases, the artist chooses the position

and the arrangement of objects that best frame the façade of the Mariakerk. It becomes a pictorial space dominated more by the aura, by the idea, by the memory of its subject than by any notion of 'reality'. The ultimate paradox is that this minutely detailed and accurate architectural rendering is, on another level, a vision of an imaginary space.

II. L'Eclisse, 1961

> One November morning a few years back I was flying over Soviet Central Asia. I was looking out over the endless desert bounding the Aral sea to the east, white and sluggish, and thinking of the film I'd be shooting in these parts next spring. A story, a world that's never been mine, that's why I like it. And while thinking of this story, watching it obediently attach itself to the landscape, I felt my thoughts sliding far away. It's always the same. Every time I start working on one film another one comes to mind (Michelangelo Antonioni, *That Bowling Alley on the Tiber: Tales of a Director,* New York, 1986).

The shot from Antonioni's *L'Eclisse* (*The Eclipse*) is an overhead view of a park. It is a small green area, speckled with a few trees and paths, dominated by the houses which line the horizon. In the park, reduced to a minute scale, are two figures, a man and a woman. The man seems to be running towards the woman. Like the trees, their shadows are cast in the midday sun. What else can we say about this image, without turning to the filmic narrative from which it is taken?

To begin with, it is illustrative of Antonioni's interest in the relationship between narrative and geographical setting: 'the story attaching itself to the landscape'. As in many of his films, each is

seen as a construct, each is seen as a function of the other. The landscape conditions the actions of the protagonists, the actions condition the way in which we see the landscape. The rocks in which the disappearance in *L'Aventura* takes place; the park in *Blow-Up*, where a murder may or may not have happened; the foggy road in *Identification of a Woman*; any number of examples may be found. In each case, the director's conception of space is both metaphorical and cartographic. Even if the story of Antonioni having the grass painted a brighter shade of green in *Blow-Up* is apocryphal, the implication remains the same. Landscape, like character, like narrative, is never fixed.

What is immediately apparent in this particular image is the way Antonioni uses scale. Like the figures in Saenredam's painting, the couple are reduced to microscopic size. And, like Saenredam, Antonioni uses perspective to focus and direct our view. Situated at the centre of the valley, the man and woman are, despite the fact that they are in a park, completely exposed.

The film itself, which meticulously details the breakdown of a relationship, is structured around an examination of their vulnerability. In addition to the stuttering communication which characterises their exchanges, we witness the process of their becoming more and more alienated from their physical surroundings. The end of the film, in fact, is a kind of abstract dissection of the mundane elements in the street which serves as the site of the final parting, culminating in a shot of a street lamp whose brightness echoes the title of the film.

This still image is again predicated on the dialectic of presence and absence. The two figures are both subjects of our gaze and absent from any kind of narrative impulse (we cannot hear them, we cannot see the expressions on their faces, we can only fix them in the landscape). As far as the geography itself, it is presented as a kind of paradoxical combination of city and country. In fact the park

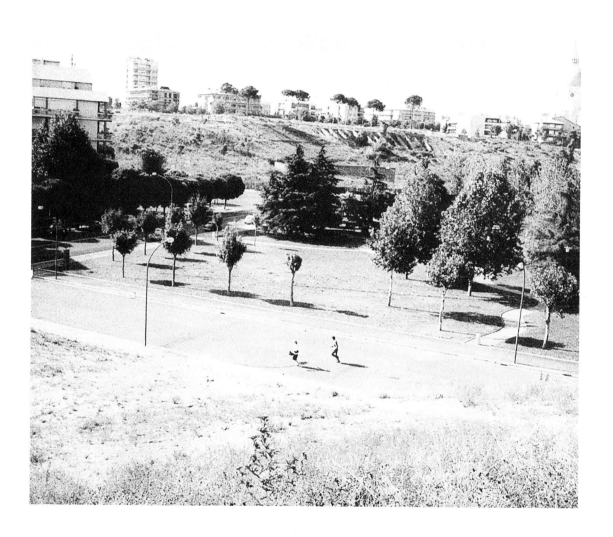

Still from *L'Eclisse* 1961, Michelangelo Antonioni

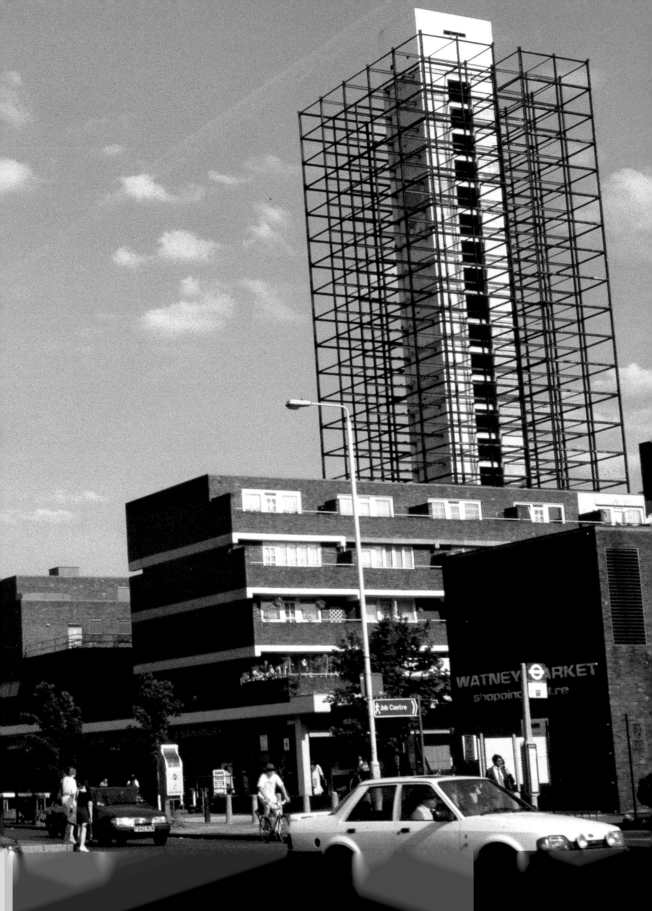

and the city may be seen as a kind of double enclosure, in which we define what we see by what is not there. An anti-narrative, an abstraction, becomes its opposite by virtue of the amount of space within which the viewer's imagination may operate.

III. Commercial Road, London E1, 1995

> It is most nearly true to say, I think, that whatever else it is, repetition for [Giovanni Battista] Vico is something that takes place inside actuality, as much inside human action in the realm of facts as inside the mind while surveying the realm of action. Indeed, repetition connects reason with raw experience (Edward Said, *The World, the Text, and the Critic,* London, 1984).

The image is of a council block in East London. The metal cage around the building predicts its impending renovation or expansion. The building itself seems like the spine of a skeleton, surrounded by the metal grid that seems endless. Like an object encased in a vitrine, the enclosure is both transparent and cautionary.

Yet, what is the structure itself? As a unit of habitation, it is based on a system of repetition, a system which is, in principle, 'democratic', in which a certain amount of identical spaces are allocated to each person or family. Like a prison, like a school, it is built on the notion of uniformity, where the concept of difference is elided. Like all skyscrapers, which 'reach' to the sky, it is structured on verticality, on the notion of height as power. Yet, in this case, the metal framing lends a certain vulnerability to the picture, a rupture in the single, uncompromising image that the skyscraper usually presents.

What we have, finally, is an image of another space which is both absent and present: present in the case of the existing structure,

the vertical that rises above the horizontal, the units arrived at by multiplication which contradict any notion of the singular, the personal; absent by virtue of the cage that surrounds it, an objectified fixing of empty space, an attempt to conquer the virtual by drawing attention to its visible spine. Neither space, real or imaginary, full or empty, exists without the other. It is an architectural sign that feeds off itself, projecting an image of dominance which is peculiarly vulnerable, empty. The combination of reason and raw experience, referred to in the quote from Said/Vico, mediated by repetition, is finally, what this image seems to suggest: a space which is more than the sum of its parts, both physical and mental, lived and imagined.

It is at this point that we may return briefly, to the images of Saenredam and Antonioni. For what unites these three disparate images – an architectural perspective, a film-still wrenched from a narrative, a late-20th century urban still life – is the ability to combine different kinds of space: the perceptual and the imaginary. In each case, what is absent determines our impression of the present: the absence of any geographical context in the case of Saenredam, an 'in your face' quality of the perspective in which our visual options are limited; the absence of the narrative in the Antonioni still, in which the characters act out a drama which becomes a function of the landscape itself; the absence of the acceptable notion of symmetry in the photograph of the council block, where repetition leads to a logical perfection which is dead on arrival.

Which brings us, finally, to Rachel Whiteread. The aim of this essay was to talk about different kinds of spaces – architectural, narrative, cinematic, photographic, social – which are predicated on the ability of the viewer to combine different realms of perception: in particular, to think of the visible and the invisible within the same construct. I chose the first two images. Rachel

Whiteread chose the third. What is apparent finally (I hope), is that these images share a common ground with her art, where the presence of the subject is both all too evident and frustratingly absent. Whiteread's space is the space between things, the space in which reason, perception and imagination meet.

Biography

Born in London in 1963, studied painting at Brighton Polytechnic 1982–1985, and sculpture at the Slade School of Art 1985–1987. Lives and works in London.

Solo exhibitions

* denotes exhibition catalogue or accompanying publication

1988
Carlile Gallery, London

1990
Ghost, Chisenhale Gallery, London

1991
Arnolfini Gallery, Bristol

1991
Karsten Schubert Ltd, London

1992
Rachel Whiteread: Recent Sculpture, Luhring Augustine Gallery, New York

Rachel Whiteread: Sculptures, Centre Cultural, Fundacion Caja Pensiones, Barcelona

Rachel Whiteread: Sculptures, Stedelijk Van Abbemuseum, Eindhoven*

1993
Galerie Claire Burrus, Paris

Rachel Whiteread: Sculptures, Museum of Contemporary Art, Chicago

House, commissioned by Artangel Trust and Beck's (corner of Grove Rd and Roman Rd, E3), London*

Rachel Whiteread: Zeichnungen, DAAD Galerie, Berlin*

1994
Rachel Whiteread: Zeichnungen, Galerie Aurel Scheibler, Cologne

Rachel Whiteread: Skulpturen/Sculptures, Kunsthalle Basel; ICA Philadelphia; ICA Boston*

Rachel Whiteread: Drawings, Luhring Augustine Gallery, New York

1995
Rachel Whiteread: Sculptures, British School, Rome

Rachel Whiteread: 'Untitled (Floor)', Karsten Schubert Ltd, London

Bentwood Chair and Bedding 1986

1996

Rachel Whiteread, Karsten Schubert Ltd, London (in collaboration with Charles Booth-Clibborn)

Rachel Whiteread: Sculptures, Luhring Augustine Gallery, New York

Rachel Whiteread: Shedding Life, Tate Gallery Liverpool*

Group exhibitions
* denotes exhibition catalogue or accompanying publication

1987
Whitworth Young Contemporaries, Manchester

1988
Riverside Open, London

Slaughterhouse Gallery, London

1989
Concept 88 Reality 89, University of Essex Exhibition Gallery, Colchester*

Whitechapel Open, London

Deichtorhallen, Hamburg*

1990
British Art Show, touring exhibition*

A Group Show: Mat Collishaw, Hanne Darboven, Angus Fairhurst, Gunther Förg, Michael Landy and Rachel Whiteread, Karsten Schubert Ltd, London

Installation photograph 1986

Marina Abramovic, Kate Blacker, Marie Bourget, Angela Bulloch, Leslie Foxcroft, Paola Pezzi, Tessa Robins, Kay Rosen, Yoko Terauchi, Marylin Weber, Rachel Whiteread, Victoria Miro Gallery, London

1991
Metropolis, Martin-Gropius-Bau, Berlin*

Kunst Europa, Kunstverein, Pforzheim

Broken English: Angela Bulloch, Ian Davenport, Anya Gallaccio, Damien Hirst, Gary Hume, Michael Landy, Sarah Staton and Rachel Whiteread, Serpentine Gallery, London*

Katharina Fritsch, Robert Gober, Reinhard Mucha, Charles Ray and Rachel Whiteread, Luhring Augustine Gallery, New York

Turner Prize Exhibition: Ian Davenport, Anish Kapoor, Fiona Rae and Rachel Whiteread, Tate Gallery, London*

Confrontaciones 91, Palacio de Velasquez, Madrid

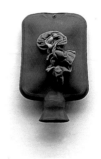

Hot Water Bottle and Cushion Cover 1986

1992
Doubletake: Collective Memory and Current Art, Hayward Gallery, London*

Fifth Anniversary Exhibition, Karsten Schubert Ltd, London

Damien Hirst, John Greenwood, Alex Landrum, Langlands and Bell, and Rachel Whiteread, Saatchi Collection, London*

Skulptur-Konzept: Carl Andre, Pedro Cabrita Reis, Tony Cragg, Dan Flavin, Donald Judd, Richard Long, Wilhelm Mundt, Ulrich Ruckriem, Serge Spitzer, Rachel Whiteread, Galerie Ludwig, Krefeld*

Documenta IX, Kassel*

Contemporary Art Initiative: Contemporary Works of Art Bought with the Help of the National Art Collections Fund, Kiddell Gallery, Sotheby's, London

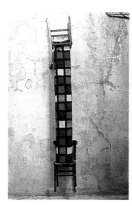

Chair and Blanket 1986

London Portfolio: Dominic Denis, Angus Fairhurst, Damien Hirst, Langlands and Bell, Michael Landy, Nicholas May, Marc Quinn, Marcus Taylor, Gavin Turk, Rachel Whiteread and Craig Wood, Karsten Schubert Ltd, London

Lili Dujourie, Jeanne Silverthorne, Pia Stadtbaumer, Rachel Whiteread, Christine Burgin Gallery, New York

Summer Group Show: Robert Barry, Keith Coventry, Angus Fairhurst, Michael Landy, Stephen Prina, Bridget Riley, Rachel Whiteread and Alison Wilding, Karsten Schubert Ltd, London

Lea Andrews, Keith Coventry, Anya Gallaccio, Liam Gillick, Damien Hirst, Gary Hume, Abigail Lane, Sarah Lucas, Steven Pippin, Marc Quinn, Marcus Taylor and Rachel Whiteread, Barbara Gladstone Gallery and Stein Gladstone Gallery, New York (curated by Clarissa Dalrymple)*

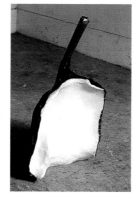

Untitled (Shovel) 1986–87

New Voices: Recent Paintings for the British Council Collection (David Ausen, Keith Coventry, Ian Davenport, Jeffrey Dennis, Peter Doig, Gary Hume, Callum Innes, Elizabeth Magill, Antoni Malinowski, Julian Opie, Fiona Rae, Michael Stubbs, Suzanne Treister, Alison Turnbull, Rachel Whiteread, Tony Cragg, Bill Woodrow, Anish Kapoor, Richard Deacon), Centre de Conference Albert Borschette, Brussels (and tour)*

1992 Sydney Biennale, Sydney*

1993
In Site - New British Sculpture, The National Museum of Contemporary Art, Oslo*

Visione Britannica, Valentina Moncada and Pino Casagrande, Rome

New Voices; Jeunes Artistes Britanniques, Musée National d'Histoire et d'Art, Luxemburg (and subsequent British Council tour until 1995)

Ear 1986

Passageworks: Geneviève Cadieux, Lili Dujourie, Dan Graham, Asta Gröting, Gary Hill and Rachel Whiteread, Rooseum Centre for Contemporary Art, Malmö*

Then and Now: Twenty-Three Years at the Serpentine Gallery, Serpentine Gallery, London

Five Works: Keith Coventry, Michael Landy, Bridget Riley, Rachel Whiteread and Alison Wilding, Karsten Schubert Ltd, London

Made Strange: New British Sculpture, Museum Ludwig, Budapest*

The Sublime Void: An Exhibition on the Memory of the Imagination, Koninklijk Museum voor Scone Kunsten, Antwerp*

Drawing the Line Against Aids, Peggy Guggenheim Colection, Venice, and Guggenheim Museum Soho, New York*

Whiteness and Wounds: Claudia Cuesta, Sarah Seager and Rachel Whiteread, The Power Plant, Toronto

Turner Prize Exhibition: Hannah Collins, Vong Phaophanit, Sean Scully and Rachel Whiteread, Tate Gallery, London*

Junge Britische Kunst: Zehn Kunstler aus der Sammlung Saatchi, Art Cologne, Cologne

Der andere Massstab:Skulpturen (Marcel Broodthaers, Eduardo Chillida, Barry Flanagan, Gunther Förg, Guido Geelen, Hubert Kiecol, Vladimir Skoda, Rosemarie Trockel, William Turnbull, Andreas Urteil, Rachel Whiteread), Edition Sabine Knust, Munich

A Decade of Collecting: Patrons of New Art Gifts 1983–1993, Tate Gallery, London

1994
Visione Britannica: Notions of Space (Alan Charlton, Alex Hartley, Mona Hatoum, Brad Lochore, Rachel Whiteread, Stephen Willats and Craig Wood), Galeria Bonomo, Rome

Drawings: Louise Bourgeois, Asta Gröting, Eva Hesse, Roni Horn, Kathy Temin, Rosemarie Trockel, Rachel Whiteread, Frith Street Gallery, London

Sense and Sensibility: Women Artists and Minimalism in the Nineties, The Museum of Modern Art, New York*

Drawing on Sculpture, Cohen Gallery, New York

Seeing The Unseen, Thirty Sheperdess Walk, N1, London*

Re Rebaudengo Collezione, Radiomarelli, Torino

Artists' Impressions: Richard Long, Victor Burgin, Antony Gormley, Helen Chadwick, Ian McKeever, Adam Lowe, Grenville Davey and Rachel Whiteread, Kettle's Yard Gallery, Cambridge

Art Unlimited: Multiples From the 1960s and 1990s, Arts Council Collection, South Bank Centre UK touring show*

1995
Double Mixte: Generique 2 (Barry X Ball, Lynne Cohen, Pascal Convert, Rachel Whiteread), Galerie Nationale du Jeu de Paume, Paris*

Ars '95, Museum of Contemporary Art and Finnish National Gallery, Helsinki*

Contemporary British Art in Print: The Publications of Charles Booth-Clibborn and his imprint The Paragon Press 1986–95, Scottish National Gallery of Modern Art, Edinburgh (and Yale Center For British Art, New Haven, December 1995-February 1996)*

Five Rooms: Richard Hamilton, Reinhard Mucha, Bruce Nauman, Bill Viola and Rachel Whiteread, Anthony d'Offay Gallery, London

British Art of the 80s and 90s: The Weltkunst Collection, Irish Museum of Modern Art, Dublin*

British Contemporary Sculpture: From Henry Moore to the 90s, Auditoria de Galicia, Compostela and Fundacio de Serralves, Porto*

Here & Now, Serpentine Gallery, London*

British Abstract Art, Part 2: Sculpture, Flowers East Gallery, London

Brilliant: New Art from London, Walker Art Centre, Minneapolis (and Contemporary Arts Museum, Houston)*

Arte Inglese: A New Generation, Galleria Maravini, Bologna, Italy

New Art in Britain, Muzeum Sztuki, Lodz, Poland*

Prints and Drawings: Recent Acquisitions 1991–1995, British Museum, London

Carnegie International 1995, Carnegie Museum of Art, Pittsburgh PA*

Istanbul Biennial, Istanbul Foundation for Culture and Arts, Turkey*

Proem: Drawings Towards Sculptures, Rubicon Gallery, Dublin*

1996
Bild-Skulpturen Skulpturen-Bild: Neuere Aspekte plastischer Kunst in der Sammlung Jung, Aachen, Suermondt-Ludwig Museum, Aachen

Ace! Arts Council Collection New Purchases, Hatton Gallery, Sunderland

Mahnmal und Gedenkstätte für die Judischen Opfer des Naziregimes in Osterreich 1938–1945, Kunsthalle Wien, Vienna*

Works on Paper from the Weltkunst Collection of British Art of the 80s and 90s, Irish Museum of Modern Art, Dublin

Selected publications

A complete bibliography of publications and reviews up to 1993 is published in *Rachel Whiteread: Plaster Sculptures*, Luhring Augustine Gallery and Karsten Schubert Ltd, 1993. A complete bibliography for *House* is published in *House*, Phaidon Press Ltd, London, 1995.

Batchelor, David, *Rachel Whiteread: Plaster Sculptures*, Karsten Schubert Ltd, London and Luhring Augustine Gallery, New York, 1993

Bond, Anthony (ed.), *The Boundary Rider: 9th Biennale of Sydney*, 1992

Cooke, Lynne, Curiger, Bice and Hilty, Greg (eds), *Doubletake: Collective Memory and Current Art*, Parkett Verlag Zurich and South Bank Centre, London, 1992

Cousins, Mark, 'Inside outcast', *tate: the art magazine 10*, Winter 1996

Debbaut, Jan (ed.), *Rachel Whiteread: Sculptures*, exh. cat., Stedelijk Van Abbemuseum, Eindhoven, 1993 (introduction by Stuart Morgan, conversation with the artist by Iwona Blazwick)

Ekstrom, Johanna, *Rachels Hus*, Dicter Wahlstrom & Widstrand, 1995

Fleissig, Peter (ed.), *Invisible Museum: Seeing The Unseen*, exh. cat., Thirty Sheperdess Walk, London, 1994

Graham-Dixon, Andrew, *Broken English*, exhibition catalogue, Serpentine Gallery, London, 1991

Hellandsjo, Karin (ed.), ' In Site: New British Sculpture', *Terskel/Threshold Magazine 9*, Museet For Samtikunst, Oslo, pp 6–127, 1993

House, limited edition book with photographs by John Davies, Artangel Trust, London, 1994

House, Phaidon Press Ltd, London, 1995 (essays by Jon Bird, John Davies, James Lingwood, Doreen Massey, Iain Sinclair, Richard Shone, Neil Thomas, Anthony Vidler, Simon Watney)

Kellein, Thomas (ed.), *Rachel Whiteread: Sculptures/Skulpturen*, exh. cat., Kunsthalle Basel, ICA Boston and ICA Philadelphia (essay by Christoph Grunenberg)

Kent, Sarah, *Shark Infested Waters*, Zwemmers, London, 1994, pp. 102–105

Meschede, Friedrich, *Rachel Whiteread: Gouachen*, exh. cat., DAAD Galerie, Berlin, Dr Cantz'sche Druckerei, Ostfildern/Stuttgart, 1993

Parkett no. 42, *Lawrence Wiener, Rachel Whiteread*, Zurich, 1994 (texts by Adam Brooks, Trevor Fairbrother, Richard Frances, Daniela Salvioni, Rudolph Schmitz, Dieter Schwartz, Neville Wakefield, Simon Watney)

Renton, Andrew and Gillick, Liam, *Technique Anglaise: Current Trends in British Art*, Thames and Hudson, One-Off Press, London and New York, 1991

Siesche, Angela, *Das Schwere und das Leichte*, Dumont, Cologne, 1995

Tazzi, Pier Luigi, *Rachel Whiteread: Sculpture*, British School at Rome, Rome 1995

Wright, Beryl (ed.), *Rachel Whiteread* (interview), Museum of Contemporary Art Chicago, 1993

Excavating the House, ICA, London, 1995. VHS video and audiotape, (contributions from Jon Bird, James Lingwod, Doreen Massey, Mark Cousins)

Rachel Whiteread: House, VHS video produced by Artangel and Hackneyed Productions, 1995. © Artangel, Hackneyed Productions and Rachel Whiteread. (26 mins., documentation of the making and destruction of *House*, made in collaboration with Rachel Whiteread)

List of Works

(all dimensions in millimetres, height ×
width × depth)
* denotes works not exhibited in Liverpool

1 *Closet* 1988
Plaster, wood and felt
1600 × 880 × 370
Private Collection
p 31

2 *Fort* 1989
Plaster and wood
750 × 1320 × 600
Nvisible Museum, London
p 33

3 * *Ghost* 1990
Plaster on steel frame
2692 × 3556 × 3175
Saatchi Collection, London
pp 15, 84, 85

4 *Untitled (Bath)* 1990
Plaster and glass
1030 × 1055 × 2095
Saatchi Collection, London
p 35

5 *Untitled (Square Sink)* 1990
Plaster
1070 × 1010 × 865
Saatchi Collection, London
pp 34, 60

6 * *Untitled* 1991
Plaster
305 × 1880 × 1372
Collection Kim Heirston, New York
p 39

7 *Untitled (Amber Bed)* 1991
Rubber
1295 × 915 × 1015
Carre d'Art, Musée d'art contemporain, Nîmes
p 25

8 * *Untitled (Black Bed)* 1991
Fibreglass and rubber
305 × 1880 × 1372
Weltkunst Foundation, Dublin
p 38

9 * *Untitled (Slab II)* 1991
Rubber
140 × 1970 × 750
Stedelijk Van Abbemuseum, Eindhoven
p 41

10 *Untitled (Floor)* 1992
Plaster
241 × 2807 × 6223
Private Collection, Switzerland
pp 42–43

11 *Untitled (Grey Bed)* 1992
Rubber and polystyrene
508 × 2388 × 1524
The Carol and Arthur Goldberg Collection
p 37

12 * *Untitled (Floor/Ceiling)* 1993
Rubber, two parts
120 × 1400 × 1200 and 25 × 1400 × 1200
Tate Gallery, London
pp 44–45

13 * *Untitled (Room)* 1993
Plaster
2750 × 3000 × 3500
Museum of Modern Art, New York
pp 65, 86–87

14 *Table and Chair (Clear)* 1994
Rubber
686 × 1016 × 749
Private Collection
p 51

15 *Untitled (Floor)* 1994–95
Resin
254 × 2743 × 3962
Tate Gallery, London
pp 46–47, 49

16 *Untitled (One Hundred Spaces)* 1995
Resin
100 units, size according to installation
Saatchi Collection, London
pp 53, 54–55

17 *Model for Judenplatz Holocaust
 Memorial* 1995
Mixed media
Height approx 30 cm
The artist
p 9

18 *Untitled (Five Shelves)* 1995–96
Plaster
250 × 950 × 225 (each unit)
Collection Tom and Charlotte Newby
p 70

19 * *Untitled (Plaster Table)* 1995–96
Plaster
720 × 880 × 1550
Private Collection, USA
p 57

20 *Demolished* 1996
Set of twelve screenprints, each 485 × 740
Courtesy Karsten Schubert Ltd and
Paragon Press, London
pp 88, 89

21 *Untitled (Double Rubber Plinth)* 1996
Rubber and polystyrene
2 units, each 685 × 760 × 865
Collection Peggy and Ralph Burnet,
Wayzata, Minnesota
p 58

22 *Untitled (Orange Bath)* 1996
Rubber and polysterene
800 × 2070 × 1100
Courtesy Karsten Schubert Ltd, London
p 59

The Trustees and Director of the Tate Gallery are indebted to the following for their generous support:

Sponsors and Donors

American Airlines
AIB Bank
Art Services Management
Arts Council of Great Britain
Australian Bicentennial Authority
Bacofoil
BMP DDB Needham
Barclays Bank Plc
The Baring Foundation
BASF
Beck's
David and Ruth Behrend Trust
The Blankstone Charitable Trust
The Boston Consulting Group
Ivor Braka Ltd
British Alcan Aluminium Plc
British Telecom
Business Sponsorship Incentive Scheme
Calouste Gulbenkian Foundation
Canadian High Commission, London and The Government of Canada
Mrs Susan Cotton, JP DL
The Cultural Relations Committee, Department of Foreign Affairs, Ireland
English Estates
The Foundation for Sport and the Arts
Girobank
Goethe Institut, Manchester
Granada Business Services
Granada Television
The Henry Moore Foundation
The Henry Moore Sculpture Trust
Ian Short Partnership
IBM United Kingdom Trust
Ibstock Building Products Limited
ICI Chemicals and Polymers Ltd

The Laura Ashley Foundation
The Littlewoods Organisation
McCollister's Moving and Storage Inc
Manchester Airport
Martinspeed Limited
Merseyside Development Corporation
Merseyside Task Force
Mobil Oil Company
Momart Plc
National Art Collections Fund
The National Heritage Arts Sponsorship Scheme (Pairing Scheme)
NSK Bearings Europe Ltd
Patrons of New Art, Friends of the Tate Gallery
Pentagram Design Ltd
Pioneer High Fidelity (G.B.) Ltd
Royal Liver Assurance
Mr John Ritblat
David M Robinson Jewellery
Samsung Electronics
Save and Prosper Educational Trust
Seok-Nam Foundation
Stanley Thomas Johnson Foundation
Tate & Lyle PLC
Tate Gallery Foundation
Tate Friends Liverpool
Tate Gallery Publishing Ltd
Unilever Plc
VideoLogic Ltd
Visiting Arts
Volkswagen

Corporate Members

BICC Cables Ltd
Crown Wallcoverings
The Littlewoods Organisation
Manweb plc
NatWest UK
Pilkington plc
United Utilities Plc

Tate Gallery Liverpool
13 September 1996 – 5 January 1997
Museo Nacional Centro de Arte Reina Sofia, Palacio de Velázquez, Madrid
11 February – 22 April 1997

Copyright © 1996 Tate Gallery Liverpool

The Façade of the Mariakerk, Utrecht by Pieter Saenredam p 90. All rights reserved
© Fundacion Coleccion Thyssen-Bornemisza Madrid

First published in paperback in the United States of America in 1997 by Thames and
Hudson Inc., 500 Fifth Avenue, New York, New York 10110
Published by arrangement with Tate Gallery Publishing Limited
All rights reserved. This book may not be reproduced in whole or in part, in any form,
without written permission from the publishers.
ISBN 0-500-27936-5
Library of Congress Catalog Card Number: 96-61179

Photographic Credits

Mike Bruce pp 9, 46–7, 49, 57, 58, 59, 70
Peter Cox pp 84, 85
Peter Harholdt pp 54–55
Volker Naumann pp 44–45, 51
Sue Ormerod pp 15, 31, 33, 38
Richard Stoner pp 54–5
Edward Woodman pp 34, 37, 41, 42–3, 60

Rosalind Krauss 'X Marks the Spot' appears in *tate: the art magazine 10*, Winter 1996,
under the title 'Making Space Matter'.

Edited by Fiona Bradley
Prepared by Tate Gallery Liverpool
Designed by Herman Lelie
Typeset by Goodfellow and Egan
Printed in Great Britain by Balding & Mansell, Kettering

LIBRARY
ST. LOUIS COMMUNITY COLLEGE
AT FLORISSANT VALLEY